THE NATIONAL GALLERY SCHOOLS OF PAINTING

Spanish and Later Italian Paintings

THE NATIONAL GALLERY SCHOOLS OF PAINTING

Spanish and Later Italian Paintings

MICHAEL HELSTON

Assistant Keeper, The National Gallery

The National Gallery, London,
in association with William Collins 1983

William Collins Sons & Co Ltd
London · Glasgow · Sydney · Auckland
Toronto · Johannesburg

BRITISH LIBRARY CATALOGUING IN PUBLICATION DATA

Helston, Michael
 Spanish and later Italian paintings.
 1. Paintings, Spanish—Exhibitions
 2. Paintings, Modern—17th–18th century—Spain—
Exhibitions
 3. Paintings, Italian—Exhibitions
 I. Title
 759.6′074 ND807

 ISBN 0–00–217183–X
 ISBN 0–00–217182–1 Pbk

First published 1983
© The Trustees of the National Gallery

Colour reproduction by
P.J. Graphics Ltd, London W3 8DH
Made and printed by
Staples Printers, Kettering, Ltd

Front cover shows a detail from *Philip IV hunting Wild Boar*
(*La Tela Real*) by Velázquez.

Back cover shows a detail from *The Last Supper at Emmaus* by
Caravaggio.

THE NATIONAL GALLERY SCHOOLS OF PAINTING

This series, published by William Collins in association with the National Gallery, offers the general reader an illustrated guide to all the schools of painting represented at the Gallery. Each volume contains fifty colour plates with a commentary by a member of the Gallery staff and a short introduction. The first three volumes in the series are:

Dutch Paintings by Christopher Brown
French Paintings after 1800 by Michael Wilson
Spanish and Later Italian Paintings by Michael Helston

Further volumes completing the series are due to be published in 1984 and 1985.

Spanish and Later Italian Paintings

The National Gallery's collection of Spanish paintings is one of the finest in the world outside Spain, although the number of paintings it contains is relatively small. In addition to the eight works by Velázquez, the greatest Spanish painter, there are pictures by El Greco, Murillo and Goya, as well as a group by less well known painters such as Ribera, Zurbarán and Valdés Leal.

The British have always been enthusiastic collectors of Spanish painting: pictures by Velázquez and Murillo were sought and admired by nineteenth-century travellers in Spain like Richard Ford. Both public and private collections in this country are consequently rich in Spanish works of high quality.

The seventeenth and eighteenth-century Italian paintings in the National Gallery are perhaps less well known: this reflects a corresponding lack of public interest during the later part of the

nineteenth and early twentieth centuries. Nevertheless the National Gallery's collection of 'baroque' Italian paintings illustrates the great variety of the period, from Caravaggio's startling naturalism, through the grand, flamboyant styles of the seventeenth century, to the bright, airy pictures of Tiepolo.

This was a period when landscapes and townscapes developed as independent subjects for painting in their own right. England eventually inherited the tradition of landscape painting, and it was mainly English travellers on the Grand Tour who patronized Canaletto, the greatest of all townscape painters, with the result that nearly all his major works are in this country.

As with the Spanish School, the National Gallery's collection of later Italian paintings is small but choice. This volume presents fifty paintings from these schools, selected and introduced by their curator.

MICHAEL HELSTON is Assistant Keeper at the National Gallery in charge of Spanish and later Italian paintings. He is the author of *Second Sight : Canaletto – Guardi*.

Spanish Paintings

Introduction

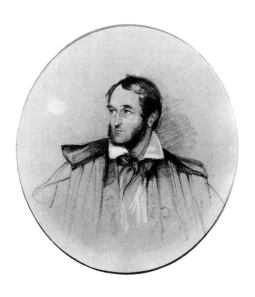

J. F. Lewis, R.A.: Richard Ford, Seville, 1883.
London, Brinsley Ford Collection.

The popularity of Spanish painting in Britain is reflected in the National Gallery's Collection, which is probably the finest outside Spain. Yet this interest developed relatively late when compared to early enthusiasm for Italian painting in this country. It was during the eighteenth century that Spanish pictures began to arrive in Britain in large numbers, when Murillo was held in especially high regard.

To begin with, collectors were far more interested in Spanish paintings than in Spain itself. During the eighteenth century, when many Britons went on the Grand Tour to Italy, Spain was hardly ever on the itinerary. Political relations between Britain and Spain had often, in the past, been difficult but the Peninsular War, when Wellington helped the Spanish against the invading French, improved this situation and travellers from Britain visited Spain more frequently.

Richard Ford, an educated English traveller, went with his wife and children to live in Spain for three years. In 1845 he published his *Hand Book for Travellers* in Spain: the book went into many editions which not only testifies to the genius of its author, but shows how heavy was the demand from an increasing number of tourists who wished to visit Spain. Ford, like many of his fellow travellers, was also a keen collector of pictures.

It is Murillo and Velázquez who inevitably dominate any survey of the collection of Spanish painting in Britain. Until the mid-nineteenth century, Murillo was regarded as the greatest Spanish artist. In spite of his often intensely Catholic subject matter, he was praised even by Ruskin (who later, however, came to regard Velázquez as superior). Although Murillo was mainly a religious painter, it is significant that his portraits and secular works were specially sought-after in this country. For example, only one of the four pictures by Murillo illustrated in this volume is of a religious subject.

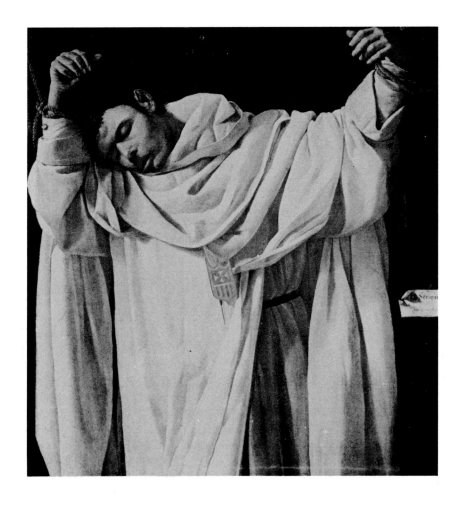

Towards the end of the nineteenth century, and partly due to
the admiration of such painters as Manet, Millais and Sargent,
Velázquez came to be even more highly esteemed than Murillo;
and he has continued to be regarded as one of the greatest not
only of Spanish painters. Others have fared less well. El Greco
was not properly appreciated until the present century and it is
still often thought, quite wrongly, that his powerfully expressive
style was the result of defective vision. Neither were Ribera or
Zurbarán as fully appreciated as Velázquez or Murillo: this is
reflected in the National Gallery's Collection.

Another gap in the Collection reflects the course of taste for
Spanish paintings in Britain. Between Velázquez in the mid-
seventeenth century and Goya at the end of the eighteenth
century, the art of painting in Spain did not cease: important
artists like Coello, Valdés Leal and Pereda are hardly known in
this country; and yet in their own time they were highly
regarded. Perhaps, following him as they did, their work has

always been overshadowed by Velázquez – and indeed Velázquez had no real followers in either style or genius. These late seventeenth-century painters looked to Italy and brought to Spain their own interpretation of the High Baroque style then current in Rome, especially the flamboyant art of Pietro da Cortona. It is only in recent years that these artists have begun to be properly studied outside Spain, although the National Gallery is fortunate in having a splendid work by Valdés Leal which entered the Collection in 1889.

Spain has always been a most fervently Catholic country. The Roman Church has often found its strongest support in the peninsula: the Dominicans and Jesuits as well as a host of minor orders were founded by Spaniards. In the late sixteenth century the edicts of the Counter Reformation, aided by the formidable Inquisition, were readily adopted: the new recommendations for the visual arts, the straightforward, clear exposition of religious subjects, appealed to Spanish artistic taste and methods. Apart from El Greco, who was in any case not a Spaniard, the one characteristic common to the great seventeenth-century Spanish painters is the clear naturalistic rendering of their chosen subjects. The nature of Spanish art made it an ideal tool for the Counter (ie "Catholic") Reformation. It is important to remember this when considering Spanish painting in Britain. The subject matter of much seventeenth-century Spanish painting cannot have held much appeal for Protestant British collectors. Yet the clarity and frankness with which these painters treated their subjects was greatly admired. One superb expression of this is Zurbarán's moving picture of St Serapion which was once in the collection of Richard Ford himself.

Velázquez's masterpiece *Las Meninas* embodies the most typical characteristics of Spanish painting. Luca Giordano later referred to this picture as 'the essence of painting'; and in the twentieth century Picasso made a comprehensive series of studies of it. Velázquez has painted a straightforward scene of a realistic group centring on the young *Infanta*. But simplicity and naturalism are here brilliantly combined with technical virtuosity (the artist seems, almost magically, to have painted the atmosphere of the room) and the picture's enigmatic quality (what is the picture that Velázquez, seen on the left, is actually painting?) Two of the works by Velázquez illustrated in this volume particularly emphasize these qualities: '*The Rokeby Venus*' and *Christ in the House of Martha and Mary* are both apparently simple pictures but contain elements that are visually ambiguous and enigmatic.

Before the seventeenth century, Spanish painting was effectively determined in character by art from outside the peninsula. During the fifteenth century the painting of the early Netherlandish school dominated native talent: political connections had

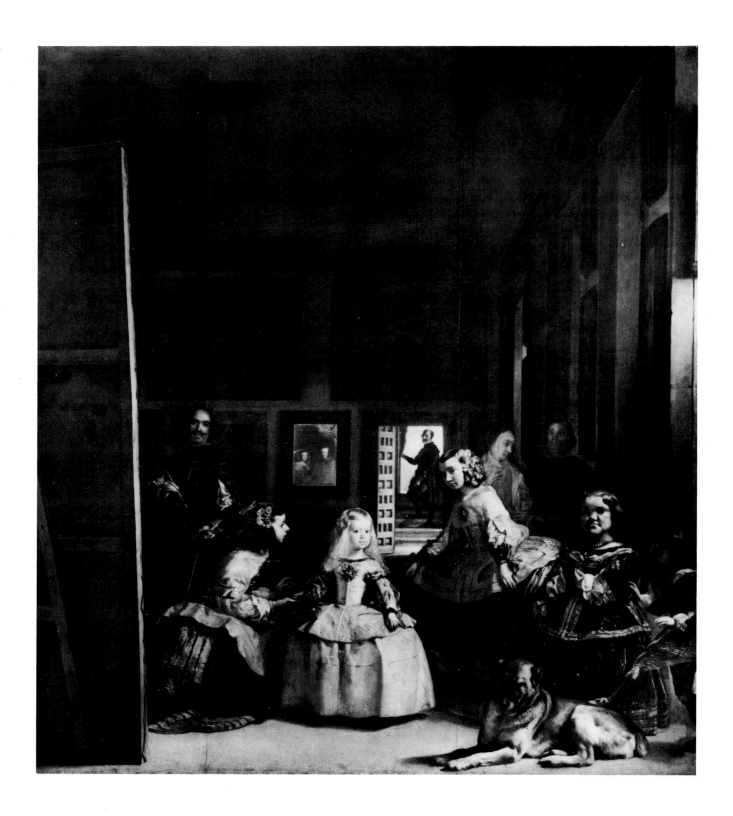

Velázquez: Las Meninas. *Madrid, Museo del Prado.*

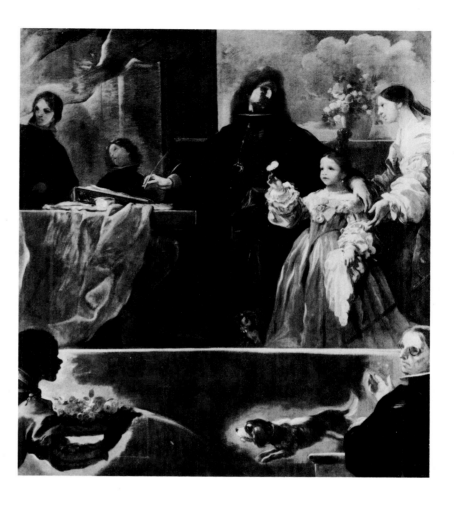

Giordano: A Homage to Velázquez. *London, National Gallery.*

made it easy for northern artists to work all over Spain, spreading their distinctive style. In the sixteenth century, the influence of Italy became stronger; again political developments fostered better communications between the two countries. But the Italian Mannerist styles of the sixteenth century, although emulated in Spain, were rarely properly understood and were not able to make much headway. With the deliberately direct styles of Italian Baroque art, especially that of Caravaggio, Spanish artists found a basis that was much more suited to their aims. But it is important to realize that while Italian painting provided an impetus, seventeenth-century Spanish painting, unlike that in previous centuries, is in no way derivative.

The Spanish painters now considered to be great all had a highly individual approach and generally had few followers. Whereas artists of the fifteenth and sixteenth centuries were dominated first by northern and then by Italian painting, El Greco, Velázquez and Murillo do not conveniently fall into any

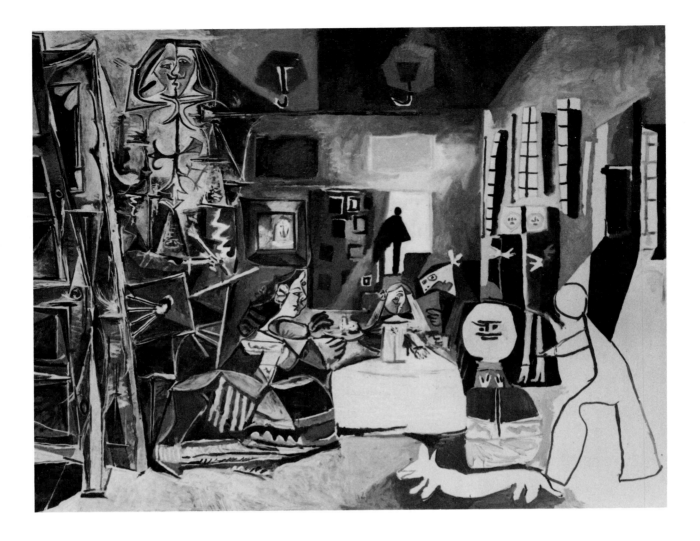

particular group. In Italy the regional schools (which during the seventeenth century were mainly those of Bologna, Naples and Rome) produced groups of artists whose styles, while recognizably individual, bear the general characteristics of the school: this rarely happened in Spain.

Subsequently, this individualistic nature of Spanish art has reaffirmed itself. Goya, whose native Zaragoza had no great tradition of painting, became a powerful yet lonely figure in the history of European civilization. And in the twentieth century the unique genius of Picasso completely altered the course of Western painting.

PLATE 1

Domenikos Theotokopoulos, *called* El Greco, 1541–1614

The Adoration of the Name of Jesus (No. 6260)

Panel, 57.8 × 34.2 cms.
Purchased 1955

El Greco went to Spain from Italy by 1577, probably in the hope of working for Philip II at the Escorial near Madrid. But the first painting he made, *The Martyrdom of St Maurice*, failed to please the king and El Greco was given no more royal commissions. He moved away from the Court to Toledo where he remained until his death in 1614. It is possible, however, that the larger version of *The Adoration of the Name of Jesus*, painted for the Escorial and still *in situ*, was intended for the king.

El Greco often made replicas of his important works to keep in his studio. More than one exists of the great *Espolio* altarpiece in the Sacristy of Toledo cathedral, painted soon after his arrival in the city. *The Adoration of the Name of Jesus*, especially if painted for Philip II, was another important work of El Greco's early years in Spain and the National Gallery version is probably a replica he made before sending the larger painting to the Escorial.

Like many of El Greco's paintings *The Adoration of the Name of Jesus* is a complicated visual image: in this case the meaning of the work is also highly complex and by no means entirely clear. It seems most likely to be a series of connected scenes. The three principal figures are the Doge of Venice with his back towards us, the Pope in the middle and, clearly recognizable in black, Philip II of Spain. These three powers had established the Holy League, a union of Christian military

forces formed to fight the growing Turkish threat. The League's greatest victory had been the sea battle of Lepanto in 1571 achieved by Philip's illegitimate brother, Don Juan. Don Juan died in 1578 and the larger picture at the Escorial may have been painted in connection with his burial there.

The three rulers are seen adoring the Name of Jesus which appears brilliantly radiant in the heavens. It was not uncommon for the very name Jesus ('at which,' St Paul had written, 'every knee shall bow') to be thought of as having real power over infidels – in this case the Turks.

The painting could thus be a commemoration of the victor of Lepanto, Don Juan, and a celebration of the military and religious triumph of the Holy League and Catholic Faith over heretics, who are neatly disposed of, defenceless in their disbelief, into the mouth of Hell. The three Christian rulers, themselves dangerously close to the monstrous jaws, are being prevented from being drawn in by their act of Faith.

The agitated composition has a medieval quality, lacking the ordered rationality of the Renaissance art El Greco had seen in Italy. Although it is sometimes assumed that he was influenced by the works by Bosch in the Spanish royal collection the bizarre quality in El Greco's art had become apparent before he even went to Spain and remained a constant feature of his always highly individual paintings.

PLATE 2

Domenikos Theotokopoulos, *called* El Greco, 1541–1614

Christ driving the Traders from the Temple

(No. 1457)

Canvas, 106.3 × 129.7 cms.
Presented by Sir J. C. Robinson 1895

The violent energy and action of this picture are typical of El Greco's work. He made several versions of the subject: this is one of the largest and latest. In earlier versions, like the one now in the Minneapolis Art Institute, painted while El Greco was still in Italy, his debt to Italian painting is clear. The use of architecture to define and deepen the space behind the action was common in the pictures of Tintoretto, who had a strong influence on the young El Greco. The dynamism of the composition recalls aspects of Michelangelo's work, which El Greco saw when visiting Rome; but later versions show the idiosyncrasies of his own mature style.

The towering central figure of Christ, tensed and ready to unleash his whip, makes the other figures seem almost insignificant. The flickering crimson of his robe is the dominant colour. El Greco often elongated the figures in his paintings to give expressive power to particular themes. (It was not, as used to be thought, due to defective eyesight: El Greco's portraits show that he had perfect control of his vision.) This elongation is especially effective in the figure of Christ where the strong sweep of his body dominates in colour, power and grace the awkwardly submissive trader whose arm is raised in defence.

It is significant that in later versions of the picture El Greco gave more emphasis to the figure of Christ: the painting has an important allegorical meaning of the sort El Greco liked to include in his work. The ideas of the Counter Reformation, like many religious doctrines in Spain, were interpreted strictly, with the formidable Inquisition enforcing the laws of the Catholic Church. This particular subject, although not very common in art, suited El Greco's intellectual tastes as a vehicle for showing the Church triumphant over heresy. The violence of the scene must have seemed appropriate at a time when military force was being used against the infidel.

The relief sculptures on either side of the archway in the background further emphasize this allegory. They show the Expulsion from Eden – the parallel with the subject of this picture is clear – and the Sacrifice of Isaac, a scene which prefigures Christ's ultimate sacrifice. But while we are reminded of the Crucifixion El Greco is not showing us the humble, crucified Saviour: we are left in no doubt that this is the all-powerful Christ of the Church Militant.

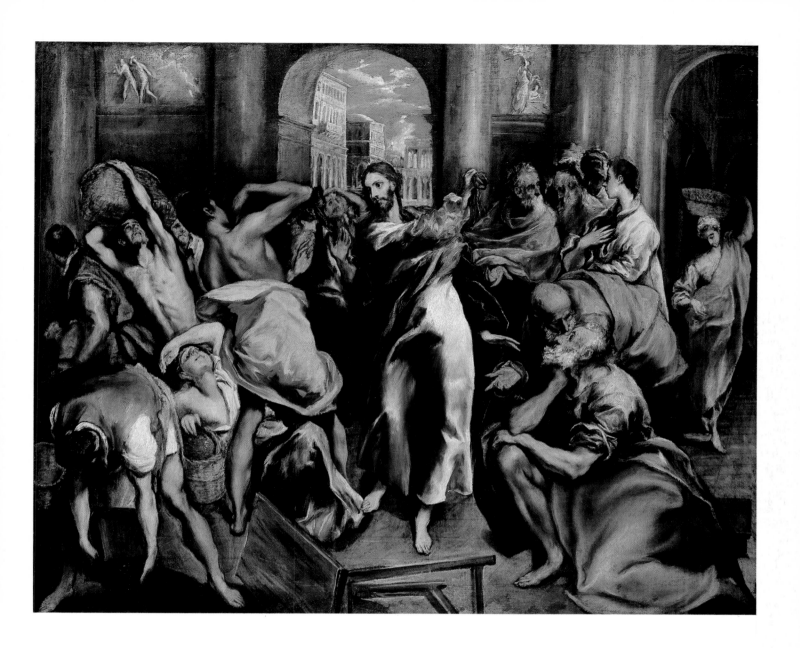

PLATE 3

Diego Velázquez, 1599–1660

Kitchen Scene with Christ in the House of Martha and Mary (No. 1375)

Canvas, 60.0 × 103.5 cms.
Bequeathed by Sir William H. Gregory 1892

Although this is a religious painting Velázquez has deliberately emphasized other elements in the picture. It is one of a group of pictures Velázquez painted before he left his birthplace, Seville, for Madrid in 1623: in fact this painting, which is dated 1618, and certain other similar early works (*The Water Carrier of Seville* in Apsley House and *The Old Woman Frying Eggs* in the National Gallery of Scotland in Edinburgh) are all painted on canvas apparently cut from the same roll. These realistic still-life and genre scenes (known in Spanish as *bodegones*) were popular in Spain during the seventeenth century and were the legacy not only of Caravaggio's naturalism but also of similar scenes by northern artists which Spanish painters knew through engravings.

Before he left for Madrid one of the main characteristics of Velázquez's art was the intensely realistic, clear portrayal of people and everyday objects. Although after two visits to Italy and life as Court Painter his style changed he never lost the feeling for this realism.

The religious subject of this picture is Christ in the house of Martha and Mary. When Mary sits at Christ's feet listening to him speak her sister Martha grumbles that she is obliged to do all the work of preparing and serving the food. The background scene shows Christ and the two women possibly at the moment when he rebukes Martha for her complaints. The petulant girl in the foreground is probably meant to be a modern (i.e. seventeenth-century) equivalent of Martha, reluctant to do her work, being reminded of the incident in the Bible by the old woman.

The garlic, pepper, eggs and fish are all painted with great realism. The brass mortar and pestle and earthenware jug with its green glaze resemble those still in everyday use in Spain today. The girl, her hand reddened from housework, is pounding garlic in the mortar and is about to add oil from the jug in order to make the traditional garlic mayonnaise often eaten with fish in Spain.

It is not entirely clear whether the background scene is a painting hanging on the wall, a mirror reflecting the scene happening in the same room or, most likely, seen through an opening in the wall giving on to the adjoining room. The ambiguities of space and the connection of a Biblical scene with a contemporary one, are features of many of Velázquez's later works. The complex interrelationship of scenes in *The Spinners* and the problems in his masterpiece, *Las Meninas*, are of a similar nature to those in *Christ in the House of Martha and Mary*. One of the most famous of these visual anomalies is the enigmatic image in the mirror of the National Gallery's '*Rokeby Venus*'.

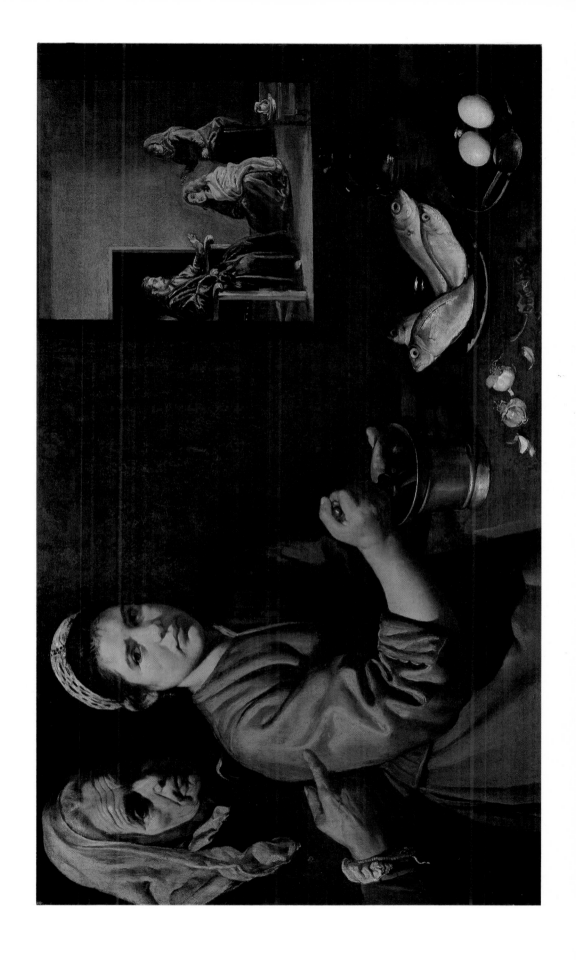

PLATE 4

Diego Velázquez, 1599–1660

St John the Evangelist on the Island of Patmos

(No. 6264)

Canvas 135.5 × 102 cms.
Purchased with the aid of a Special Grant and
contributions from the Pilgrim Trust and the National
Art-Collections Fund 1956

This and the following picture were probably painted to be hung together. Their subjects are closely related and were especially important at the time the pictures were painted, around 1618. It was in this year that the cult of the Immaculate Conception, so crucial to the beliefs of the people of Seville, began to receive the recognition of the Roman Catholic Church. St John's vision on the island of Patmos was relevant to the development of the dogma.

The Immaculate Conception is not described in the Bible and thus has no basis in 'historical' fact: this was one of the Church's main objections. St John's vision of the Woman of the Apocalypse, which does appear in the Bible, therefore became the textual basis for the iconography of the Immaculate Conception (see following page).

As a young artist in Seville Velázquez would have been aware of this controversy and it would have seemed natural for him to be given a commission to paint what was, to an extent, a pictorial justification of the Immaculate Conception. These are among his earliest known pictures and were in fact probably painted on canvas from the same roll as the group of paintings that includes *Christ in the House of Martha and Mary* (plate 3).

Seated close to his symbolic eagle, St John is shown as a young man. This in itself is unusual: Velázquez's father-in-law, Francisco Pacheco, in his treatise on art published in 1649, was to recommend that St John, when shown on Patmos, be portrayed as an old man. But Velázquez often broke the accepted rules, usually intelligently and with good reason. Here it probably seemed more sensible to show St John as an ordinary youth as the picture was to be a pendant to *The Immaculate Conception* where the Virgin is modelled on a young girl. The highly naturalistic approach to both these paintings was to remain a constant feature of Velázquez's art.

As in many of Velázquez's paintings there are clear marks (here to the right of the tree) where the artist has wiped his brush clean of one colour or tried out another. This seemingly casual attitude to his work became more apparent in his later, more relaxed style of painting. Here it contrasts sharply with the realistic portrayal and seriousness of the subject.

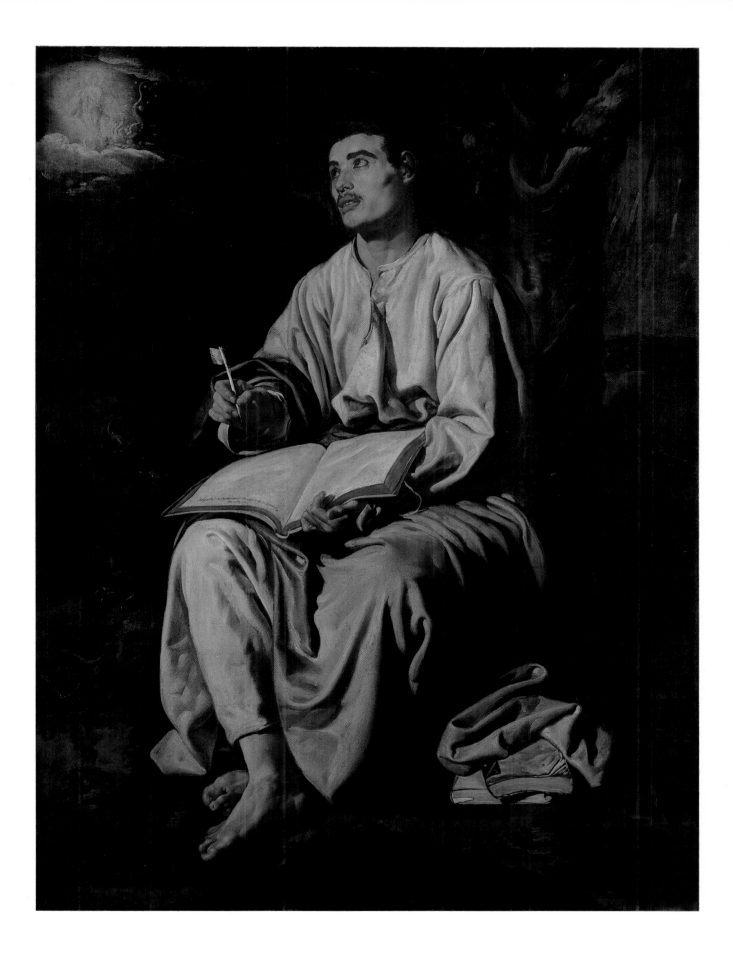

PLATE 5

Diego Velázquez, 1599–1660

The Immaculate Conception (No. 6424)

Canvas 135 × 101.6 cms.
Purchased with the aid of the National Art-Collections
Fund and an anonymous donation 1974

Although the Immaculate Conception was one of the most popular subjects in seventeenth-century Spanish painting, especially in Seville, the dogma was only grudgingly accepted by the Church in Rome and not given official recognition until 1671. What we see is not Christ being conceived in the Virgin's womb (that is shown in the Annunciation) but the Virgin herself appearing to us in a vision that shows her to be pure, arriving on the earth without the strain of original sin. It is as if she were a creation of God's will.

The obscure nature of the subject, which does not appear in the Bible, makes it untypical of seventeenth-century painting where Counter Reformation policy required the clear, simple portrayal of Biblical subjects or scenes from the lives of the saints.

This painting is not only one of Velázquez's earliest known works but it is also one of the earliest representations of the Immaculate Conception in Spanish art. The Virgin is seen in what had become the traditional way of showing her Immaculate Conception, as the Woman of the Apocalypse. The iconography comes from St John's vision on the island of Patmos (see previous page). When he was writing the Apocalypse the Virgin appeared to him 'clothed with the sun, and the moon under her feet and upon her head a crown of twelve stars' (Revelation XII, 1–4).

Velázquez has included several other iconographic references to the Immaculate Conception drawn from various parts of the Bible: the temple, fountain, city, ship and even the dawn all have specific meanings and were frequently used to reinforce the as yet unofficial dogma. By comparison to these the Virgin appears monumental on the translucent moon: because of this grandeur her innocence and purity seem especially poignant.

This painting and the one on the preceding page were first recorded hanging together in the convent of the Shod Carmelites in Seville, the foundation for which the paintings were probably originally painted. The Carmelites were particularly devoted, more so even than other Spanish religious Orders, to the dogma of the Immaculate Conception.

Although in later years Velázquez managed to avoid painting religious pictures, for which his art was not generally suited, this early work is one of the more moving renderings of what was perhaps the most important religious subject in seventeenth-century Spanish painting.

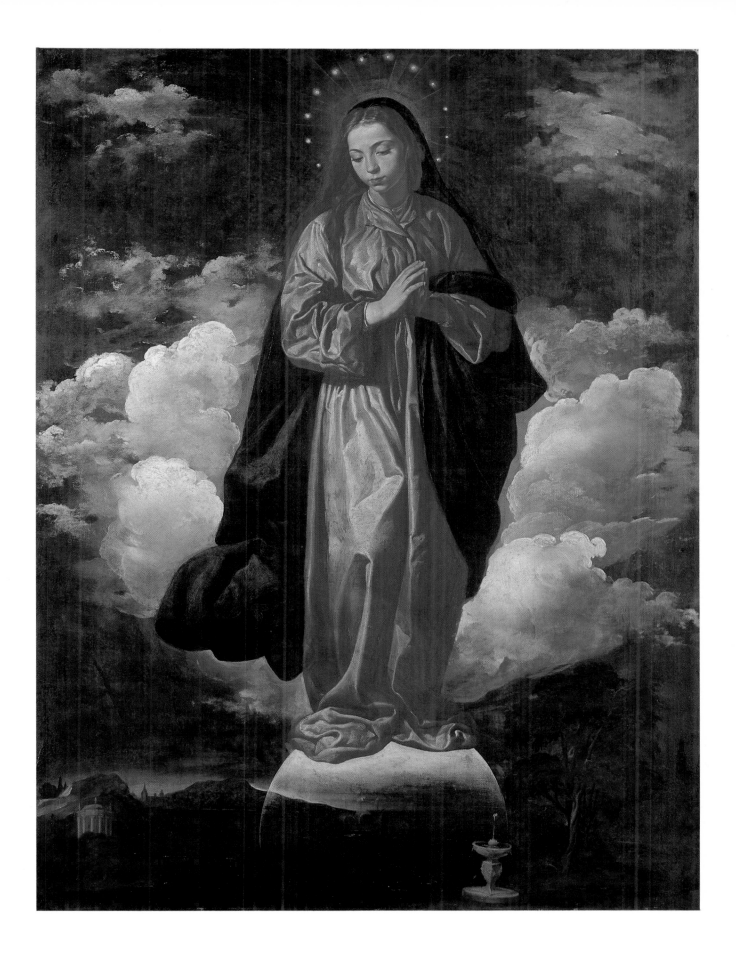

PLATE 6

Diego Velázquez, 1599–1660

Philip IV of Spain in Brown and Silver (No. 1129)

Canvas, 199.5 × 113 cms.
Signed: Señor/Diego Velasqŭz./Pintor de V. Mg.
Purchased 1882

When Velázquez finally left Seville in 1623 it was for a secure position at Court in Madrid as Painter to the King. From the first time that Velázquez portrayed Philip IV the king declared that no other artist would paint him. An exception was made when Rubens visited the Spanish Court in 1628, but this probably met with Velázquez's approval as the two artists became friends and genuinely admired each other's very different work.

It may have been Rubens who in 1629 urged Velázquez to travel to Italy where he stayed for nearly two years (1629–31). Only after several requests from Philip IV himself was Velázquez persuaded to come back. This magnificent portrait was probably the first Velázquez painted of his royal patron on his return to Madrid.

By painting the king in this splendid costume Velázquez was breaking with the strong tradition of portraying Spanish monarchs dressed simply, in black. The power of the kings of Spain had been legendary, and real, and there was no need for extravagant displays of sumptuous costume and impressive riches. But by the early 1630s, when this picture was painted, the Spanish Empire was in trouble. Many dominions of the Crown, both overseas and within the Iberian peninsula, were becoming restless; and this unrest was soon to lead to open rebellion. It is possible that Philip felt the need to be portrayed as the magnificent monarch he aspired to be, the 'Planet King', a need his ancestors had not felt. The portrait now in the Frick Collection, New York, is the only other to show the king in an elaborate costume.

The painting is unusual in other respects. It is clearly signed on the paper Philip holds and Velázquez, who rarely signed his pictures, records not only his name but his position at Court as well – 'Painter to His Majesty'. The picture is also in superb condition: the brushwork is still fresh and thickly impasted, giving a realistic sparkle to the silver of Philip's costume. Although he painted many portraits of Philip IV Velázquez gave this one particular attention, returning to work on it months, possibly years, after he began.

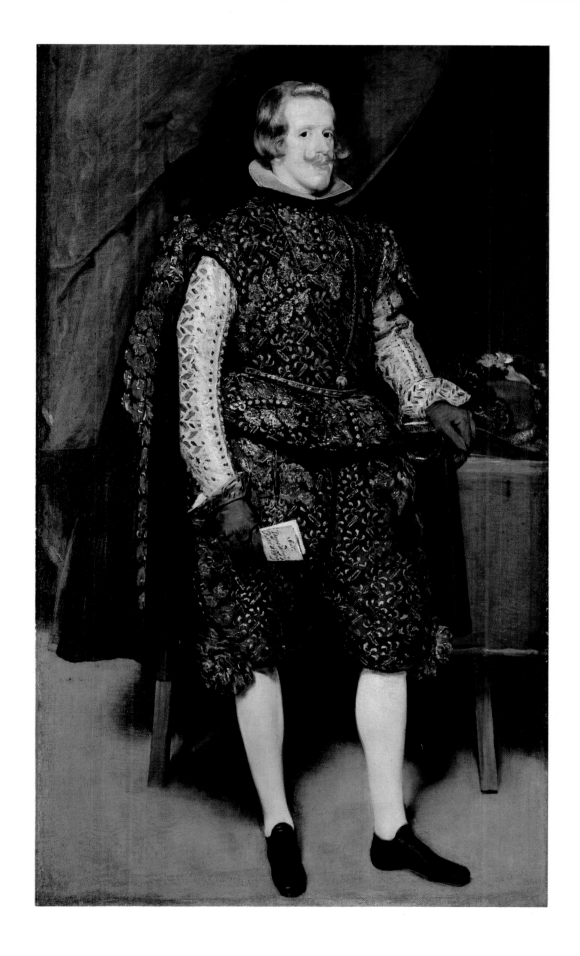

PLATE 7

Diego Velázquez, 1599–1660

Philip IV hunting Wild Boar (No. 197)
['La Tela Real']

Canvas, 182 × 302 cms.
Purchased 1846

This picture was probably painted for Philip IV's hunting lodge, the Torre de la Parada, near Madrid. This explains the emphasis of the picture, hanging as it did among a group of landscape paintings: it is the largest of Velázquez's few known landscapes, and one with which he probably had assistance.

Philip IV preferred hunting and riding to the business of running the complex bureaucracy of the Spanish Empire. This he entrusted to a chief minister. The Count-Duke of Olivares was the king's favourite when the Boar Hunt was painted: with his prominent moustache he can be seen to the right of the king who is jousting a charging boar.

Boar hunting was one of the many outdoor sports enjoyed by the Spanish royal family. However, the complex arrangements made it expensive. The scrubby countryside around Madrid was abundant in wild animals like boar, but for the king to hunt them they were driven into a large canvas enclosure (*tela* in Spanish). Here the king or one of his courtiers would attack the boar with a long, forked lance (*horquilla*), supplies of which can be seen stacked against a tree in the enclosure. The boar would later be finished off by dogs, which Velázquez has shown at the left of the painting. Sometimes, though, a wounded boar would still be able to get the better of a dog: in the foreground on the left a group of people gather round a dog that has been gored to death; and the only person in the picture who looks out at us is drawing our attention to this.

More than the hunting scene it is the groups of people milling around in the foreground who form the real subject of the picture. Velázquez has shown us as much about daily life in seventeenth-century Spain as about boar hunting. We are positioned directly in front of the young man drinking deeply from a jug: his companion, like the youth on the left, is trying to draw attention to the dead dog. Behind the drinking youth is a group of three elegant gentlemen in conversation, one of whom has his crimson coat slung casually over his shoulder. All around the enclosure people are involved in various activities, some watching the royal hunt, others trying, in vain, to get a mule to move, while others simply lie about gossiping.

Meanwhile, in the enclosure, Queen Isabella sits in her carriage preferring not to watch her husband attacking a boar, but rather to gaze at the crowd.

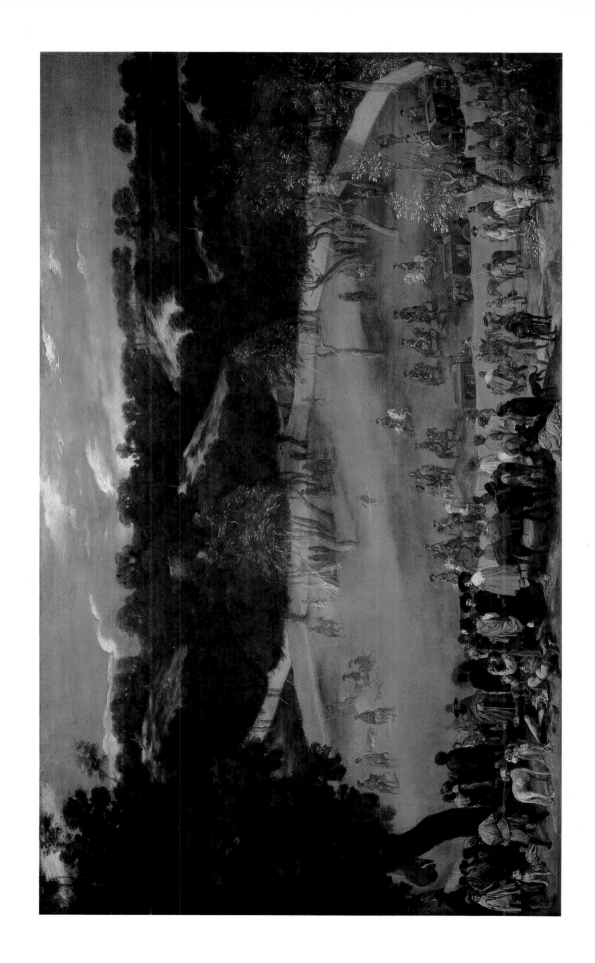

PLATE 8

Diego Velázquez, 1599–1660

The Toilet of Venus (No. 2057)
['The Rokeby Venus']

Canvas, 122.5 × 177.0 cms.
Presented by the National Art-Collections Fund 1906

The 'Rokeby Venus' is so called because it used to hang at Rokeby Hall in Yorkshire, in the collection of the Morritt family. It was sold in 1905 and later presented to the National Gallery. Before its arrival in England in 1813 the painting had been owned by a succession of Spanish nobles close to the Court, beginning in the seventeenth century with the Marqués del Carpio, one of Philip IV's viceroys in Naples. For a nude to have been painted in seventeenth-century Spain, where public morals were closely controlled by the Inquisition, is unusual. It would have had to be commissioned by someone close to the king, who alone could escape the censure of the Inquisition, most probably the Marqués del Carpio himself.

Velázquez was in Italy from 1649 to 1651: he may have painted the picture just before or even during the visit, as it is recorded in an inventory of the Marqués del Carpio's pictures in 1651.

The unusual composition has led to much speculation as to Velázquez's source for Venus' pose: antique statues of reclining female figures, a Rembrandt etching and even Michelangelo have all been suggested. But the 'Rokeby Venus' is closest in spirit to the sensuous nudes by Titian in the Spanish royal collection (now in the Prado, Madrid). Velázquez was probably aware of all these works, but this highly original picture is nonetheless his own invention.

Velázquez has focussed our attention on the nude figure in various ways: the image in the mirror is deliberately vague, and Cupid, in spite of his youth, is darker and coarser than the bright figure of the goddess lying on the dark silk sheet.

At first Velázquez (as X-rays have revealed) showed Venus in profile but, perhaps finding it too distracting, he altered this, eventually showing only the side and back of Venus' head with its loosely painted bun of hair. The only suggestion of Venus' face is the vague reflection in the mirror: yet the face that appears there hardly seems to belong to the goddess of love: it is more like the face of a peasant girl, cheeks rosy from outdoor life. This blurred reflection makes Venus' body seem even more clearly defined: it also serves to deepen the illusion of space within the picture.

The depiction of space, 'aerial perspective', was something that always fascinated Velázquez. (Plate 3, painted some thirty years earlier, also shows this interest.) The series of different coloured fabrics draped across the picture may at first have seemed monotonous or flat: the device of the mirror breaks across this pattern. The clever reflection of the pink ribbons adds in a subtle way to the spatial illusion and also shows how sensitive Velázquez could be in his seemingly casual way.

Velázquez learnt much from the works of Titian both in Italy and in the splendid royal collection in Madrid. The Venetian technique of modelling form with colour, making severe outlines unnecessary, was especially important for him. The blurred edges of Venus' body bear this out. But for Velázquez such technical skills were only the means to an end: the achievement in his art of a balance between artifice and nature.

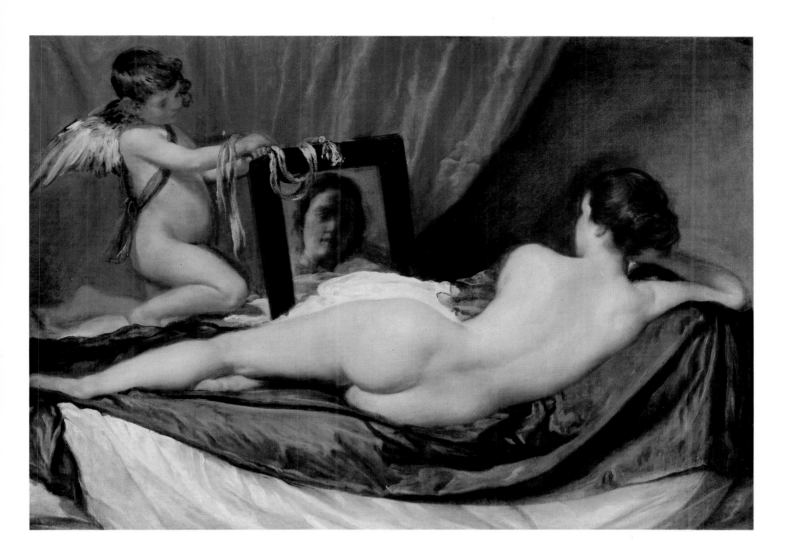

PLATE 9

Jusepe de Ribera, 1591 (?)–1652

Jacob with the Flock of Laban (fragment) (No. 244)

Canvas, 132 × c.118 cms.
Signed and dated: Jusepe de Ribera espãnol/academico
Romano/F 1638 (?)
Bequeathed by Lord Colborne 1854

Ribera occupies a unique place in the history of seventeenth-century painting. Born in Spain around 1591 he moved to Naples at the age of twenty-five. Naples was at the time part of the huge Spanish Empire and Ribera, who always regarded himself as a Spaniard, although apparently he never returned to Spain, was much closer than his compatriots to the mainstream developments of Baroque painting in Italy.

A characteristic of Spanish painting, especially at the beginning of the seventeenth-century, was the general use of a highly naturalistic style. This was developed in part from Caravaggio but also came from the down-to-earth nature of Spaniards (with whom the complex Mannerist styles of sixteenth-century Italy never made much headway). Ribera's work is typical of this aspect of Spanish art. Contact with Italy and contemporary Italian art served to heighten this element in his paintings.

Ribera's intense realism was such that he has often been regarded, especially·in this country, as a cruel painter. His stark renderings of the naked bodies of old men as saints, and terrifying scenes of martyrdom, in part justify this accusation of brutal realism. But Ribera could also channel his naturalistic talents into pictures of great tenderness.

Jacob with the Flock of Laban is one of Ribera's gentle paintings. Unfortunately it has been cut down on both sides, mainly on the left; it was originally a horizontal picture (an old copy in Madrid shows the full composition). It illustrates the Old Testament story in which Jacob, having been deceived by his uncle Laban for fourteen years, eventually retaliated. Laban told Jacob that he might have any speckled sheep in his flock, having first hidden all the speckled ones away. Jacob half-peeled sticks and placed them in the water before the white sheep as they came down to drink. Faced with these stripes the sheep miraculously conceived speckled young which Jacob was able to claim for himself. After six years he amassed a vast flock of speckled sheep and took them away.

It is a tranquil, contemplative picture: Jacob has endured many years of toil with great patience. Ribera shows him looking towards Heaven, his patience tempered with gentle determination.

PLATE 10

Bartolomé Esteban Murillo, 1617–1682

Self-Portrait (No. 6153)

Canvas, 122.0 × 107.0 cms.
Purchased 1953

Murillo was born in Seville and, unlike his older compatriot, Velázquez, seldom left the city. His artistic training was usual for the day and the fame he achieved at an early age lasted throughout his career. There was a steady demand for his work and he was always able to make a proper living from his paintings for himself and his large family. He was not a temperamental artist and always produced the work required of him. An active member of the Brotherhood of the Caridad, a religious organization who helped the many sick and needy of the city, Murillo was, like many of his friends, a deeply religious man. The one great sadness of his life was that he outlived six of his nine children. Murillo died as a result of a fall from a scaffolding while at work on a painting.

This self-portrait was probably painted around 1670 when Murillo was in his early fifties. The inscription reveals that it was done for his children. Although he is known mainly for his religious paintings this picture alone would establish Murillo as one of the finest portrait painters in seventeenth-century Spain. As with most of Murillo's work the subject is clearly expressed, in detail where necessary, but without any superfluous clutter. This particular painting, which is on finer canvas than he usually used, allowing greater delicacy of detail, is also visually witty and ambiguous.

The artist has painted himself in a frame supported on a ledge in front of a niche. The oval frame is held by a fanciful outer support with finger-like tendrils of stone. Murillo has tantalizingly placed his own fingers outside the frame. The oval frame implies that this is a painting of a painting; Murillo's projecting fingers ruin this illusion but add to the realistic effect of the portrait: we are being asked to believe that this is the artist himself on the ledge.

Murillo shows us the tools of his trade resting on the ledge either side of the picture frame: a drawing in red chalk, the chalk in its holder, a wooden rule and a pair of brass dividers. On the other side a palette, lying on some brushes, shows colours ready for use, mixed into their oil medium. The neat arrangement of colours on the palette and the presence of precision instruments confirm the impression, already apparent in this and other paintings, that Murillo's life, like his art, was clearly thought out and well ordered.

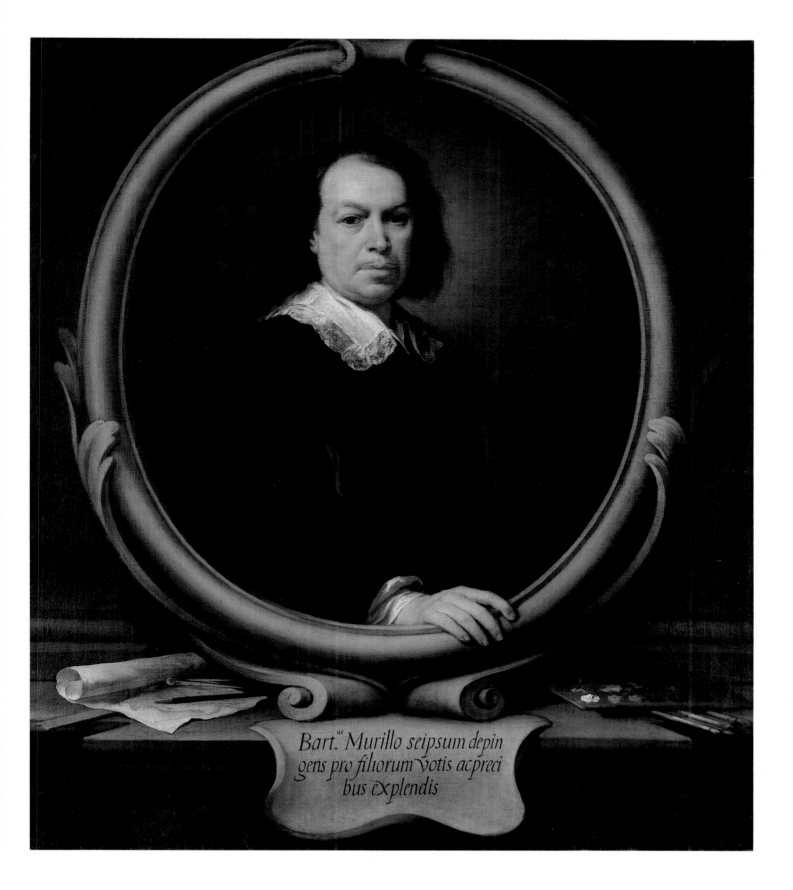

Bart.^{us} Murillo seipsum depin
gens pro filiorum votis acpreci
bus explendis

PLATE 11

Bartolomé Esteban Murillo, 1617–1682

Portrait of Don Justino de Neve (No. 6448)

Canvas, 206.0 × 129.5 cms.
Purchased 1979

This grand portrait, clear and strong in its composition, is of Murillo's great friend and patron, Don Justino de Neve. A fellow native of Seville, Don Justino was instrumental in securing several major commissions for the artist as well as ordering pictures, such as this one, for himself. Although Murillo moved house many times he and Don Justino were close neighbours when the latter arranged for him to paint the important series of paintings for the church of S. Maria la Blanca: and one can be sure that Don Justino was closely involved in devising the exact subject matter.

Don Justino was a prebendary of Seville cathedral, that is, he was 'employed' by the cathedral authorities. Seville cathedral was and remains one of the largest in the world and also, due to Seville's position as gateway to the New World, one of the richest. Some of Murillo's most important early commissions were for the cathedral chapter, helping establish his reputation as the most sought after painter in the city.

Don Justino would probably have been involved in the complicated dispute surrounding certain dogmas, such as the Immaculate Conception, that were so important to the Church of Spain, but which were less well thought of by the Church of Rome. It was necessary to clarify these problems, both for the authorities in Rome and so that ordinary people could understand them. From Murillo's portrait one feels that Don Justino was eminently suited to this kind of work. His gaze is clear and intelligent, with a sparkle in his dark eyes, enlivening the otherwise sombre face, white from a life confined to libraries and churches. (Murillo in his self-portrait appears much more bronzed after exposure to the southern sun.) Yet as well as portraying Don Justino's icy intellect, Murillo, sympathetically, gives his face the trace of a smile.

The grandeur of the portrait reflects the fact that both men were, by 1665, when the picture was painted, highly eminent in their respective professions. But, as with the smile that makes Don Justino more approachable, Murillo has tempered the monumentality of the painting by the addition of the little dog.

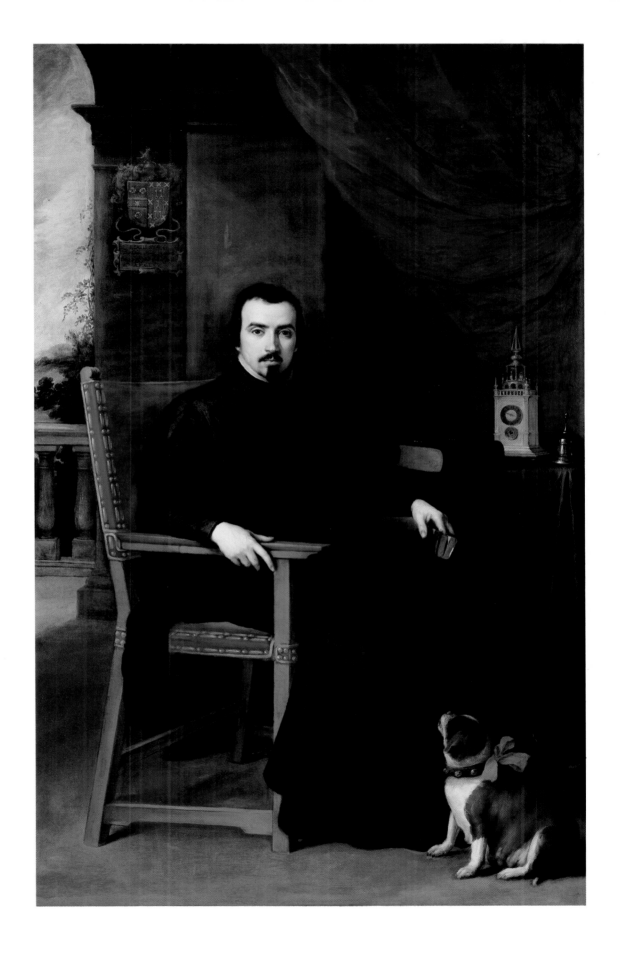

PLATE 12

Bartolomé Estaban Murillo, 1617–1682

A Peasant Boy leaning on a Sill (No. 74)

Canvas, 52 × c. 38.5 cms.
Presented by M. M. Zachary 1826

Of all Murillo's paintings it was those of street urchins and grubby, grinning children that most appealed to British taste during the nineteenth century when Murillo was at the height of his popularity in this country. While it is clear that other great Spanish masters were appreciated for their abilities as painters (the intensely Catholic subject matter of many Spanish paintings could hardly have appealed to Protestant taste) it was perhaps the subject matter of these particular pictures of ragamuffins by Murillo that appealed to the British. Because of the 'chocolate box' sentimentality attached to this picture and others by Murillo in this genre it is especially important to remember the circumstances in which they were painted.

During the seventeenth century Seville was several times stricken with plague, usually followed by terrible famine. Few families escaped tragedy: Murillo himself lost several children. Yet in these pictures of street urchins the boys rarely appear ill or under-nourished and are sometimes actually eating. As in this picture they are often shown grinning happily. So in spite of first-hand experience of the terrible conditions that afflicted his city Murillo's art reflects a lasting sense of optimism.

These pictures are close in spirit to the 'picaresque' novels that enjoyed tremendous popularity in seventeenth-century Spain. Cervantes himself wrote in this genre the Exemplary Novels – short stories concerning various young rogues and their adventures. Most famous, however, was the anonymous *Lazarillo de Tormes* which, like the Cervantes stories, is still widely read in Spain. Lazarillo's exploits take him round the country, getting work where he can, begging food and drink but nevertheless enjoying himself; and Lazarillo was not above picking the odd pocket.

But these novels usually have a moral, albeit a simple one: that it is best to be honest, kind and decent even if circumstances force one astray every now and then. While Murillo's grinning boy has seen the unpleasant side of life and has probably picked pockets and filched fruit from shops, his smile, because there is no real malice in him, seems to indicate genuine happiness.

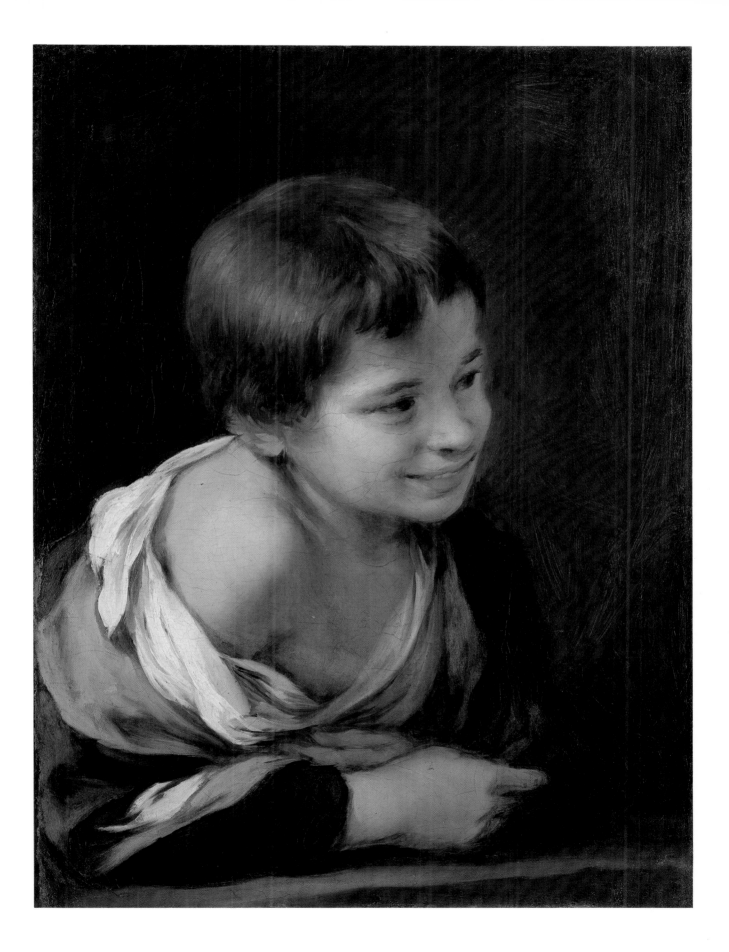

PLATE 13

Bartolomé Esteban Murillo, 1617–1682

The Two Trinities (No. 13)
['The Pedroso Murillo']

Canvas, 293 × 207 cms.
Purchased 1837

Murillo's religious paintings, which comprise the majority of his work, exemplify the Counter Reformation teachings on the arts. He presented subjects clearly and simply, even though the subjects themselves were sometimes rather obscure.

Like the Immaculate Conception the 'Two Trinities' is a subject not specifically referred to in the Bible. It is connected to the passage (Luke II 41–52) which relates how the young Christ, after the Feast of the Passover, remained behind at the Temple in Jerusalem, talking with the Doctors. His earthly parents, realizing that he was not with them, returned to the city to look for him. When they found him Mary asked, 'Son, why has thou thus dealt with us?', to which Christ replied, 'I must be about my father's business.'

The painting is a clear visual explanation of Christ's reference to his heavenly father as opposed to Joseph. The composition shows Christ as part of both families: reading vertically, with God the Father and the Holy Ghost he forms the Holy Trinity, while across the picture he forms, with Mary and Joseph, an earthly, family Trinity. (See also Pittoni's *Nativity*, plate 36.)

Murillo was a superb draughtsman and was always keen to portray physical beauty, but not in the way that Michelangelo delighted in drawing the human form. Whenever he could he showed saints, and especially the Virgin, at their most beautiful. The lovely Virgin Mary in *The Two Trinities* appears in other pictures by Murillo: in a painting of Santa Justa (Dallas, Meadows Museum) she is even shown in the same attitude. The figure of Joseph, a tolerant seeming man in late middle age, also appears in other paintings such as the charming *Holy Family* in the Duke of Devonshire's collection at Chatsworth.

The Two Trinities is one of the last pictures that Murillo painted, probably for the Marqués del Pedroso in Cádiz. While he retained his delicate, controlled sense of colouring, his style towards the end of his life became looser with open, free brushwork (his 'vaprous' style, as Palomino described it). But any changes that occurred to his art during his life did not affect the clarity, or sincerity, of his religious painting.

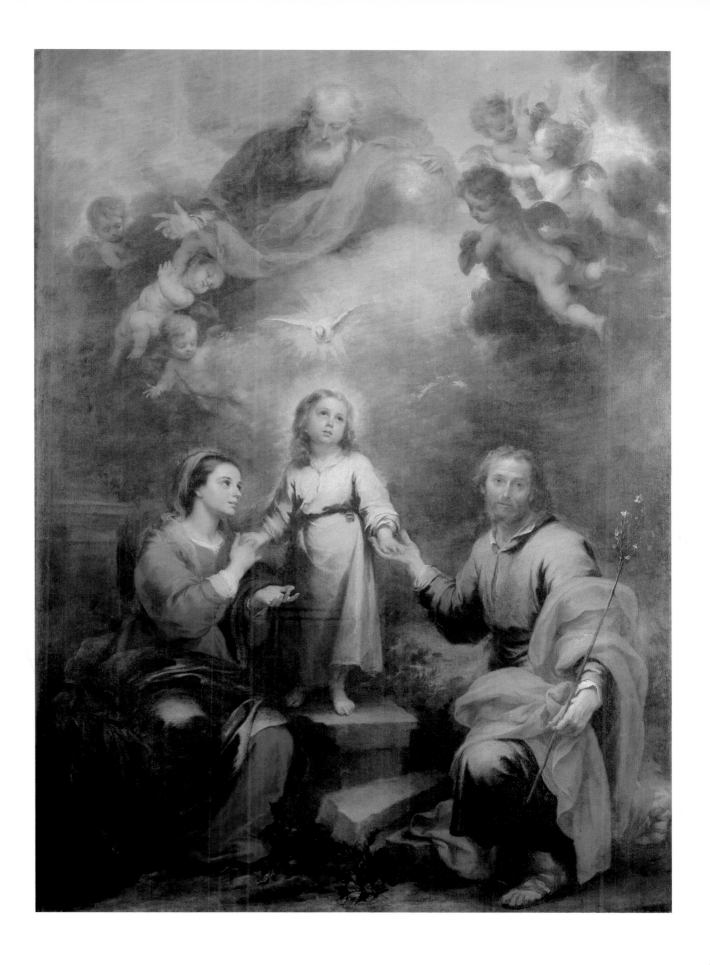

PLATE 14

Francisco de Zurbarán, 1598–1664

St Francis in Meditation (No. 230)

Canvas, 152 × 99 cms.
Purchased 1853

Zurbarán was an almost exact contemporary of Velázquez. But whereas Velázquez quickly established himself at Court in Madrid, becoming a high-ranking officer in the palace, Zurbarán visited the capital infrequently, spending his life working mainly in the south of Spain for monasteries and private patrons.

In the early work of Velázquez the influence of Caravaggio can be seen in the clear, naturalistic presentation of people and objects. Zurbarán was also keenly interested in the strong light effects in Caravaggio's work.

As with Murillo's paintings Zurbarán's art adheres strongly to the doctrines of the Counter Reformation. Devotional pictures like this *St Francis in Meditation* are a manifestation of the religious zeal felt so strongly in seventeenth-century Spain. One has only to remember St Ignatius Loyola, founder of the Jesuit Order, and the visionary St Teresa of Avila, both Spaniards, to appreciate the context of Zurbarán's picture.

The theme of St Francis in Meditation, with its emphasis on death, was often used by religious missionary organizations like the Jesuits, whose activities made them the spearhead of Counter Reformation policy. One of the many spiritual exercises encouraged by the Jesuits was meditation on death. In 1687 a Jesuit handbook on these spiritual exercises recommended that meditation on death 'should take place with the windows closed as darkness helps impress the horror of death upon the soul: likewise it helps to hold a skull'. Zurbarán's picture virtually illustrates this text, showing how sympathetically he responded to the practical methods of the Counter Reformation and the Jesuits.

St Francis is shown holding a skull in a dark place with dramatic light striking him obliquely. His habit is patched and frayed: on his hands are the stigmata, the wounds of the Crucifixion he had received from a vision of Christ. Zurbarán has anachronistically visualized St Francis, a twelfth-century saint, conforming to the seventeenth-century Jesuit recommendations for prayer. The saint's attitude is not merely pensive: his meditation, having begun with contemplation of the skull, has taken him into a deep, trance-like state. While the light falls on him from above the picture, St Francis' gaze also penetrates far beyond the picture space.

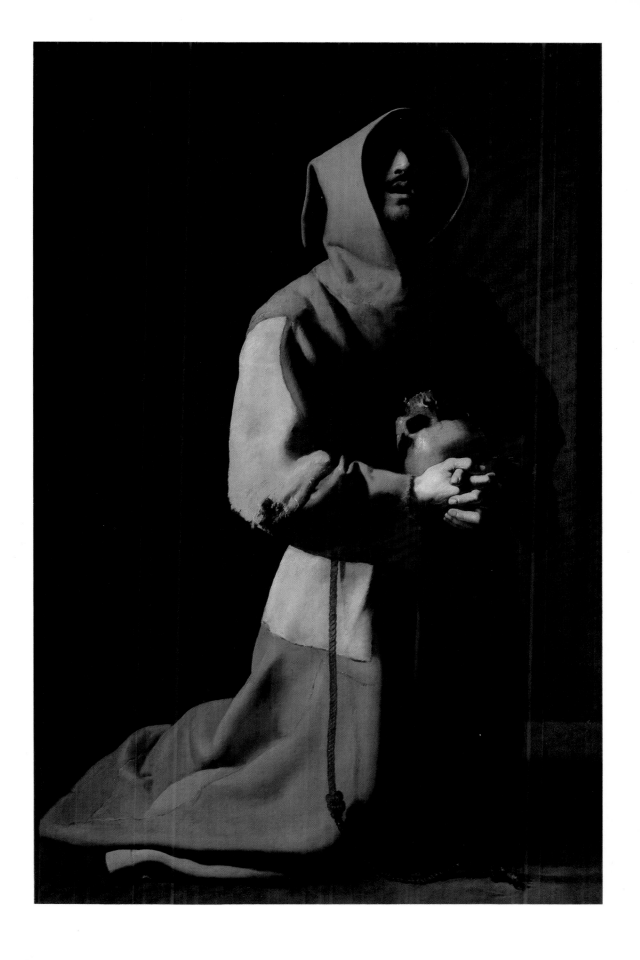

PLATE 15

Juan de Valdés Leal, 1622–1690

The Immaculate Conception with Two Donors (No. 1291)

Canvas, 189.7 × 204.5 cms.
Signed: Juan/Baldes (in monogram) Fac/A⁽ᵒ?⁾ 1661
Purchased 1889

Valdés Leal was only four years younger than his great compatriot, Murillo. But while Murillo's art is firmly based in the first half of the seventeenth century Valdés Leal's work reflects the art of contemporary painters from both Italy and Spain.

Although he was from Seville and eventually settled there, rivalling even Murillo, Valdés Leal worked in several cities in the south of Spain. Perhaps it was his willingness to travel that increased his awareness of contemporary painters like Claudio Coello, the principal painter in Madrid during the late seventeenth century. While Murillo's work is always clear and simple both in style and subject matter Valdés Leal worked in a more agitated manner and his subjects are often extremely complicated.

This version of the Immaculate Conception illustrates how Valdés Leal has presented one of the most common subjects of seventeenth-century Spain in the most intricate way. He seems to have included all the iconographic material available on the subject. Earlier in the century, when the dogma of the Immaculate Conception had not yet been officially accepted by the Church, certain clerics, mainly from Seville, searched the Bible for any reference, however slight, which would support the claim for the absolute purity of the Virgin. Valdés Leal has included all the symbols yielded by this research in his version of the subject. The palm, the olive branch, the lily, the rose and the mirror all refer to various passages in the Bible which were used to support the dogma. He has even included a reference to the Virgin as Queen of Heaven by showing cherubs holding a crown above her head.

The figures at the bottom of the picture are portraits of the donors. The woman is clearly much older than the man but the relationship between the two people (it has been suggested that she is his mother) is not indicated anywhere in the picture. The *biretta* on the table behind the man probably means that he was a cleric; and, especially if he was a native of Seville, the subject of the picture would be of great importance to him.

The style of Valdés Leal becomes easier to understand when it is compared with that of Murillo. Murillo, like Velázquez, often used sombre colouring and, although he increasingly brightened his palette, Murillo's use of colour is generally marked by the control and restraint of the early seventeenth century. Valdés Leal's exuberant colouring and flamboyant style derives from mainstream developments in contemporary Italian painting: his work fits much more easily with our idea of the Baroque than does that of Velázquez or Murillo.

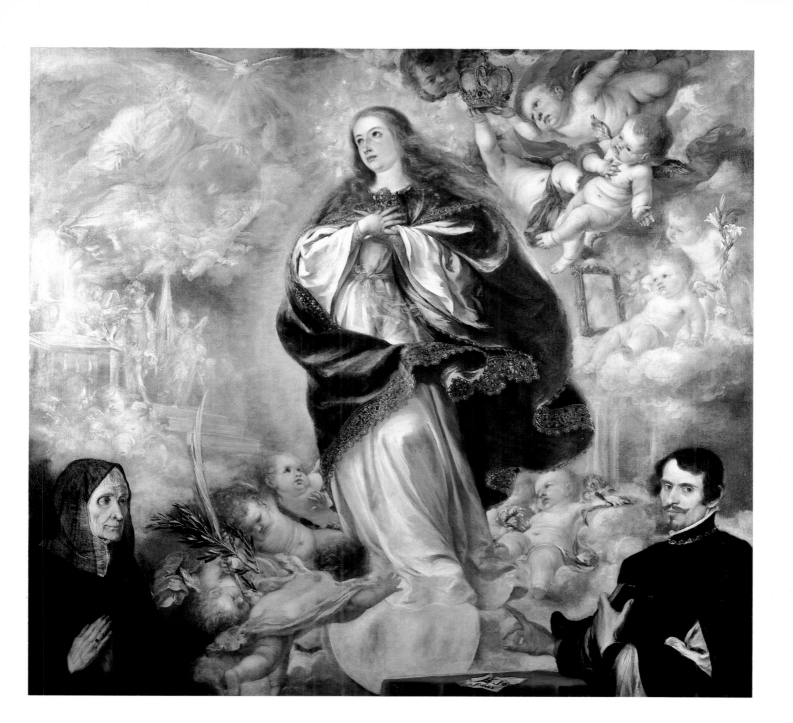

PLATE 16

Francisco de Goya, 1746–1828

A Picnic (No. 1471)

Canvas, 41.3 × 25.8 cms.
Purchased 1896

When Goya settled in Madrid after leaving his native Zaragoza in 1775 one of his first tasks was to prepare cartoons for the tapestries to be made in the royal works. This picture is probably a sketch for one of these cartoons, although it was not paid for until 1799.

Goya was working on the tapestries until 1791. In the following year he suffered the terrible illness that made him deaf and rendered his health precarious for the rest of his life. It was this illness, coupled with the wave of political unrest caused by the French Revolution, that caused a change in Goya's outlook which later became apparent in his paintings. This picnic scene, however, shows none of the brooding cynicism or fear seen in the so-called 'black paintings'. It is an image of eighteenth-century charm.

The group of young people are seated in a landscape resembling the Madrid countryside in the early days of summer. They would have begun their meal seated more formally around the spread table cloth, and have now relaxed after consuming the contents of the picnic basket and at least one bottle of wine. The man in the centre, fortified by a draught of wine from the remaining bottle, is chatting merrily to the rather demure girl in front of him. Three of the group have tactfully moved apart and talk amongst themselves while keeping an eye on what is going on. One youth in a patterned waistcoat lies on his stomach perhaps contemplating the insects that move around in the grass: and one of the party, having succumbed to the post-prandial haze of a warm day, is taking a siesta.

This delightful scene is typical of much of Goya's work of the 1770s and 80s. It reflects his own attitude to life at that period. It is known that Goya enjoyed life and various outdoor pursuits: and his name was often romantically linked to certain fashionable ladies. It is joyful scenes such as this one that make us aware of how acute was the personal tragedy of his later years.

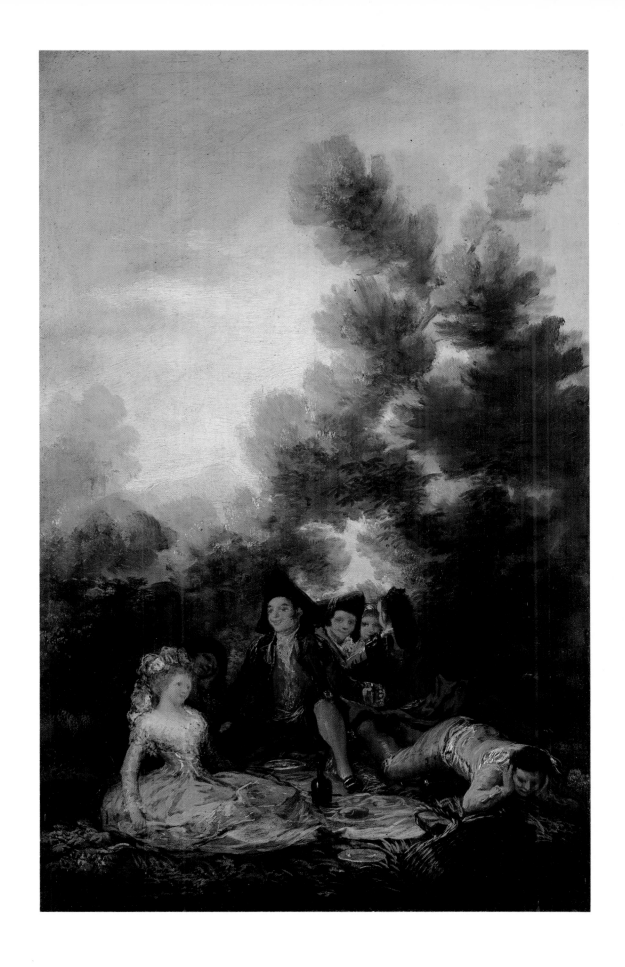

PLATE 17

Francisco de Goya, 1746–1828

Don Andrés del Peral (No. 1951)

Panel, 95.0 × 65.7 cms.
Presented by Sir George Donaldson 1904

Peral was a contemporary of Goya and also worked as a painter and gilder in the Court at Madrid: Goya would have known him well. He exhibited this portrait at the Real Academia de San Fernando in 1798 to great public acclaim.

Goya claimed to have three teachers: Rembrandt, Velázquez and Nature. In his famous series of etchings Goya looked to Rembrandt for inspiration. There had been hardly any tradition of etching in Spain before Goya's extraordinary work in the medium. In portraiture it was to Velázquez that Goya turned: and Velázquez himself had looked to Nature for inspiration. The magnificent array of Velázquez's portraits in the Spanish royal collection deeply impressed Goya and his own portraits consciously continue the tradition established by the great seventeenth-century master.

Like the sitters in many of Velázquez's works Don Andrés is shown against a simple dark background. Goya sometimes used landscape backgrounds in his earlier portraits, but in later years they are less frequent. Again like Velázquez (and Nature) Goya did not flatter his sitters in any way and Don Andrés del Peral is made to appear quite unsympathetic. His expression is dry, almost sneering. The position of his arms, one placed aggressively on his hip, the other with the hand hidden inside the tunic, underlines a sense of hostility.

The frankness of the portrait is offset by the very delicate colouring. The flowery waistcoat somehow seems inappropriate to the sitter, perhaps reminding us of a brighter side of his character. The splendid brushwork around the loose collar again recalls Velázquez.

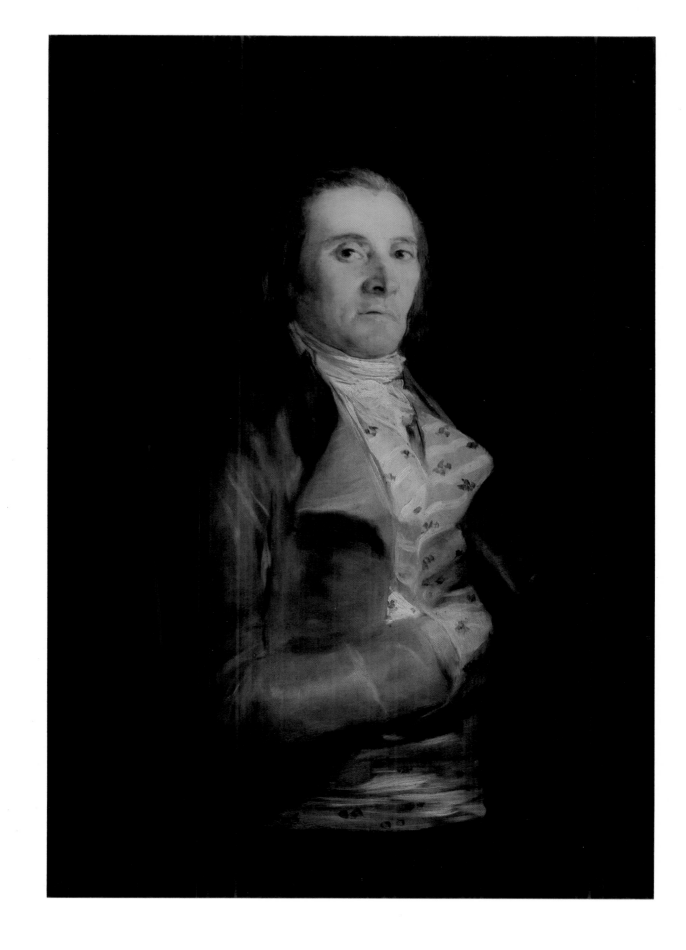

PLATE 18

Francisco de Goya, 1746–1828

Doña Isabel de Porcel (No. 1473)

Canvas, 82.0 × 54.6 cms.
Purchased 1896

In 1805 Goya exhibited this portrait of the 'wife of Don Antonio de Porcel' at the Real Academia de San Fernando, the equivalent in Madrid of London's Royal Academy. Doña Isabel's husband was an important government official and a friend of Goya. Goya had been made Painter to the King in 1786 and since then had been in demand as a portrait painter by people in the highest circles of Spanish society. It is mainly through Goya's portraits that we are permitted to view the leading families and dignitaries of Spain in the turbulent years after the French Revolution and during the Peninsular Wars.

Goya has complemented Doña Isabel's natural, clear beauty by showing her fashionably dressed in the costume of a *maja*. This fashion was established in the later years of the eighteenth century when it was considered pleasantly *risqué* for aristocratic women to dress as local girls from Madrid and promenade on the banks of the Manzanares (Madrid's river) in these coquettish costumes. These clothes became very fashionable

although it is difficult to understand such aristocratic dalliance continuing after the shock of the French Revolution.

The elaborate *mantilla*, or head dress, and lace shawl are typical of *maja* costumes. Along with Doña Isabel's big, bright eyes and the loose hair curling on to her cheek, they add to the informal air of the portrait. The black lace is painted over the rich, pink fabric with immense technical flair: once again Goya has drawn freely from the works of the great Spanish Old Masters. Both El Greco and Velázquez used this technique of showing the colour underneath through the diaphanous skein of a surplice or, as here, a shawl.

Goya's sympathetic approach to the sitter, with her gentle, full-lipped smile, makes one aware that Goya found her attractive. Recent restoration shows that he painted Doña Isabel over a male portrait that was already nearly completed—implying, perhaps, that Goya was eager to get on with this portrait.

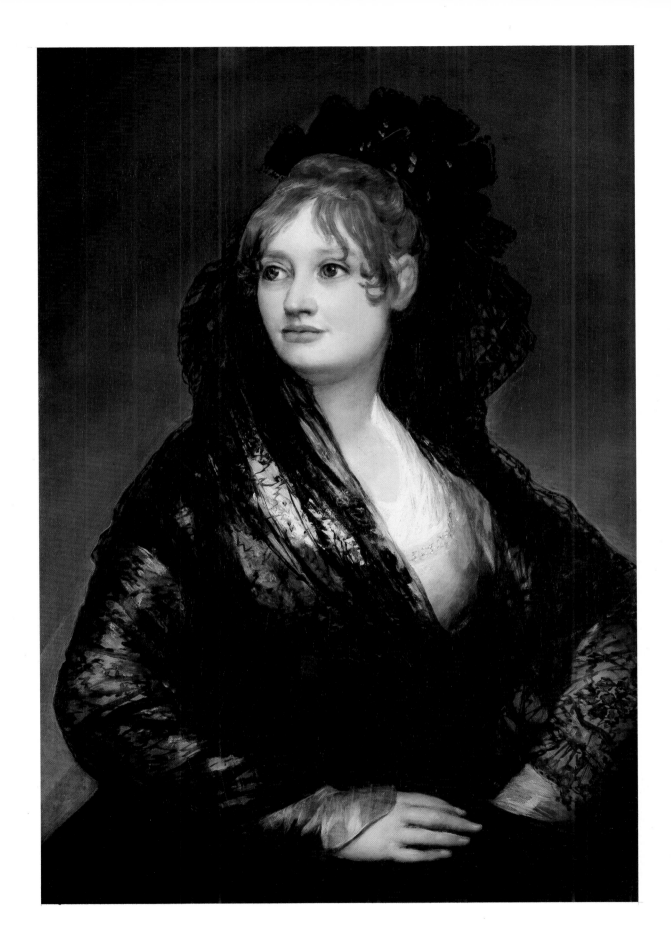

PLATE 19

Francisco de Goya, 1746–1828

The Duke of Wellington (No. 6322)

Panel, 64.3 × 52.4 cms.
Purchased with aid from the Wolfson Foundation and a
special Exchequer grant 1961

After the Battle of Salamanca the victorious Duke (then Earl) of Wellington entered Madrid on 12 August 1812. While the Peninsular War was by no means over the Duke's arrival in the capital, forcing the French to withdraw, was regarded as a triumph.

Napoleon had placed his brother Joseph on the Spanish throne in 1808. Joseph had been a well-intentioned ruler, though hated by the Spaniards. When Wellington finally defeated the French in 1814 at the Battle of Vitoria, he was seen as a liberator. Goya, whose sympathies were liberal, would have been pleased to paint the Duke for this reason alone: but the liveliness of this portrait probably reflects Goya's admiration for the man as well as his deeds. He painted two other portraits of the Duke: a half-length now in Washington and a grand equestrian portrait which hangs in Apsley House.

The Duke is shown wearing an impressive array of medals and decorations. The group of three badges on the right of his tunic are the Order of the Bath (top), Portugal's Order of the Tower and Sword (below right) and the Spanish Order of San Fernando. The pink (although it should be red) and blue sashes he wears are connected with these Orders.

While he was in Madrid the Duke received his greatest honour to date: Spain conferred on him the Order of the Golden Fleece. He was obliged to request permission from the Prince Regent in England before he could accept, and Goya had probably already painted this portrait by then. Thus the painting had to be altered, notably in the tunic, before Goya was able to add the Duke's newly received Golden Fleece which hangs around his neck.

The cross below the Fleece is another addition, by Goya, of 1814 when the Duke was next in Madrid. It is the Military Gold Cross, awarded to officers in the Peninsular War: each of the four arms of the cross records a battle in which the recipient had fought. If the number of battles exceeded four the extra names were placed on clasps worn on a ribbon above. The Duke has three clasps in this picture and eventually received nine, representing a total of thirteen battles. One can see clearly that the ribbon is painted over the oval Peninsular Medal the Duke had been wearing when Goya originally painted the portrait in 1812: this was superseded by the Military Gold Cross in 1813 and Goya must have taken the opportunity of the Duke's visit to Madrid in the following year to bring the portrait up to date.

During these years Wellington was effectively in control of Spain, ruling almost as a monarch until Ferdinand VII was restored to the Spanish throne in 1814. As Goya remained Painter to the King, a position he had held since 1786, it is possible to consider this portrait (as well as the Washington and Apsley House pictures) in the context of Spanish royal portraiture.

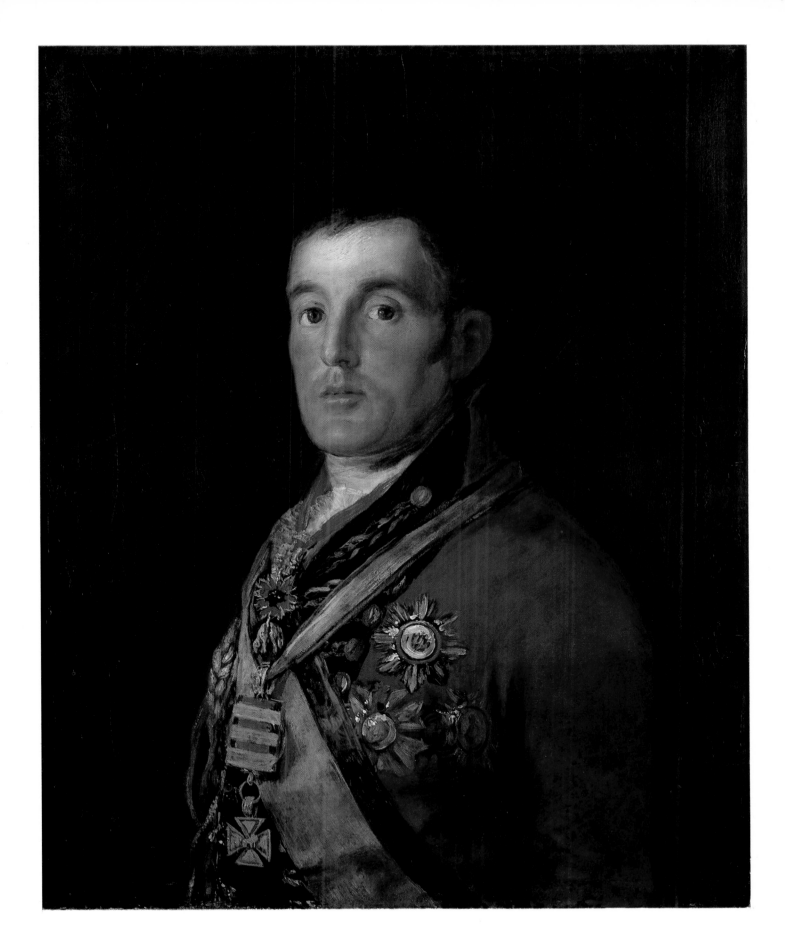

Later Italian Paintings

Introduction

At the end of the sixteenth century certain Italian painters deliberately undertook to change the form of contemporary painting. Several circumstances contributed to this upheaval. The most important were, firstly, the decrees from the Council of Trent concerning the visual arts, and secondly, the ideas and work of two very different Italian painters, Annibale Carracci and Caravaggio.

The Council of Trent, which issued several bulls clearly formalizing the doctrines of the Counter Reformation, realized that the intellectually and visually complex Mannerist style, prevalent almost all over Italy in the late sixteenth century, was not suitable for the dissemination of the Church's message to the masses. It was important to the Roman Church that the Protestant threat from the north be held back by what was effectively artistic propaganda. The Council called for straightforward concise depictions of Biblical stories and scenes from the lives of the saints. Above all they required clarity: what was the point of obscuring the main subject of a picture with complex visual imagery?

Both Annibale Carracci and Caravaggio also emphatically rejected the artistic patterns of the late sixteenth century; and both, to a degree, conformed to the tenets of the Council of Trent. But their individual approaches differed widely.

Annibale Carracci adopted a carefully structured method in his art. He turned to the Old Masters, Raphael, Titian and Correggio, and made painstaking studies of their work. Mannerist painters like Pontormo and Parmigianino often used strange unnatural distortions in their work in order to achieve an effect of elegance and grace. Although these pictures can be extremely beautiful it is easy to see how such rarified works were difficult to understand. Annibale's work by comparison is striking in its clarity; and his assiduous, diligent method was ideal for

propagating his style through formal means: with other members of his family who were also painters Annibale Carracci founded in 1585 an academy of painting in Bologna. Many of the most important artists of the early seventeenth century were to be trained in the Carracci academy.

Caravaggio's approach to painting was entirely different. Although formally trained in Milan he soon rebelled against the idea of academic study and boasted that he worked only from nature; indeed his early style is clear and naturalistic. His religious paintings were designed to communicate their message to ordinary people: but his obsession with naturalism was such that he even used ordinary people as his models. This caused concern in the Church, for although it was desirable to have religious subjects clearly depicted, permitting a greater general understanding, was it proper to show the apostles as elderly peasants or have the Virgin Mary on her deathbed modelled on the body of a dead prostitute? The artistic sensation Caravaggio caused in Rome was matched by his turbulent personal life. He eventually had to flee the city after killing a man in a brawl. In spite of the stir created by his work, and unlike Annibale Carracci, Caravaggio did not have a group of studio assistants and followers who would continue working in his style. However, there were many artists from all over Europe who, throughout the seventeenth century, drew on Caravaggio's art for inspiration.

The work of these two painters, then, formed the artistic foundation on which Baroque painting was to build. But the development of painting throughout the century was more complex than this clear-cut beginning as, inevitably, painters experimented with and combined the two exciting new styles. The result, especially in the first half of the century, was a rich variety of Baroque painting when individual artists such as Domenichino, Reni and Guercino all looked to a common source.

Rome became the undisputed centre of Italian art during the seventeenth century. The Pope and his circle of cardinals were patrons of the greatest importance. It was here towards the middle of the century that the style known as High Baroque developed. Pietro da Cortona was the leading exponent: the large cycles of frescoes with which he decorated the palaces and churches of Rome were highly influential and he attracted a large group of followers who worked in his characteristic flamboyant style. Some of the illusionistic effects achieved by these artists are particularly striking. Andrea Pozzo's ceiling of the church of S. Ignazio is perhaps the most astonishing of its kind. The theatrical and realistic effect (which can be properly seen only from a single viewpoint) is such that it is often difficult to make out where the real architecture ends and the painted illusion begins. The

Andrea Pozzo: Allegory of the Missionary Work of the Jesuits. *Rome, Church of S. Ignazio. Fresco on ceiling of nave.*

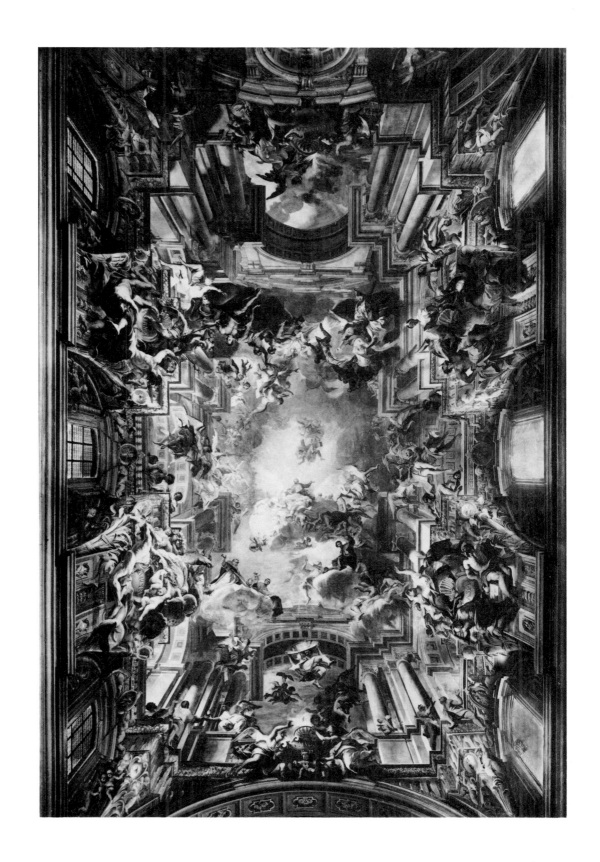

National Gallery unfortunately has no large mature work by Pietro da Cortona or any of his followers, a serious gap in the Collection.

As well as Bologna and Rome, Naples was an important centre for seventeenth-century Italian painting. Although Naples was at the time under Spanish rule the influence of contemporary Italian painting was, naturally, strong. Caravaggio, after leaving Rome, went to Naples where his art caused an immediate sensation. Many Neapolitans worked exclusively in his style and the dramatic effects of light in Caravaggio's work became a standard feature in much Neapolitan painting. But the influence of Bolognese artists, some of whom worked for short periods in the city, was also felt.

Later in the century Luca Giordano, a Neapolitan by birth and a pupil of Ribera, was able to transcend the limits of his particular school. He worked in Spain as well as all over Italy and his reputation was international. He drew freely on the art of both contemporaries and predecessors, working for a while in Rome with Pietro da Cortona. His fluent technique and brilliant luminous effects paved the way for artists of the eighteenth century, many of whom greatly admired Giordano.

During the eighteenth century Venice once again became a major centre of Italian art. Both in fresco and on canvas Giovanni Battista Tiepolo dominated religious and mythological painting while Canaletto led the field of view painting. The two artists were contemporaries and their two very different kinds of painting, which seldom mixed, made Venice doubly important. After Tiepolo's death in 1770 his son continued to work in a similar style: Guardi took over from Canaletto as the leading view painter in the city. The death of these two artists marked the end of the great age of Italian painting.

During the seventeenth century contemporary Italian Baroque painting was almost as sought-after in England as the work of the great masters of the High Renaissance. Several collections, including the Royal Collection, had in them works by Annibale Carracci and Guido Reni. This continued in the eighteenth century when Britons began to travel in large numbers on the Grand Tour. But they also began to buy and commission contemporary paintings notably from Canaletto and Batoni, both of whom painted mostly for British patrons. British taste, however, remained broadly conservative and although several Italian, especially Venetian, painters even journeyed to this country they were not much patronized by the British in Italy. It seems that the dazzling art of Tiepolo simply did not appeal to the British.

By the time the National Gallery was founded in 1824 there was a great deal of Baroque painting in Britain and during the Gallery's early years seventeenth-century Italian painting

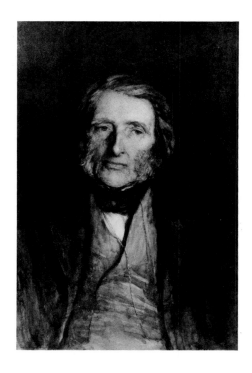

H. von Herkomer: John Ruskin. *London, National Portrait Gallery.*

formed a substantial proportion of the Collection. Of the ten pictures, for example, by Guido Reni or his studio now in the National Gallery, nine had entered the collection before 1860. Conversely there were then no pictures by Tiepolo: the Gallery's now considerable holding of that artist's work was acquired mainly in the middle years of the present century.

When the great Manchester exhibition of paintings was held in 1857 Annibale Carracci's *The Three Maries* was by far the most popular painting there. It was later bequeathed to the National Gallery – and all the other paintings by Annibale now in the Collection were already in Trafalgar Square by the time the Manchester exhibition opened. But if popular taste approved of seventeenth-century painting the then Director of the National Gallery, Sir Charles Eastlake, had begun to concentrate on collecting earlier Italian art. Ruskin, concerned as he was with the artistic education of the working classes, said that they should 'not be allowed to look at a Bolognese painting'. This attitude to Baroque art soon affected the general opinions of people in Britain. It is only recently that Baroque painting has begun to recover its popularity and the names of Reni, Carracci and Giordano are no longer derided. But this period of obscurity is reflected in the National Gallery where there are many gaps in this part of the Collection.

PLATE 20

Michelangelo Merisi da Caravaggio, 1573–1610

The Supper at Emmaus (No. 172)

Canvas, 141 × 196.2 cms.
Presented by Lord Vernon 1839

The clear naturalism, powerful drama and strong lighting of this picture are characteristic of the new, revolutionary style of painting, developed by Caravaggio alone, and passed on by him to many followers all over Europe. Along with the bright, but more academic work of Annibale Carracci Caravaggio's paintings provided the foundation for much of the art of the Baroque period. Later in his career the sombre, almost monochrome paintings he made became crucial for Neapolitan art: but it is the style exemplified by this picture that caused such a sensation in Rome at the beginning of the seventeenth century.

Michelangelo Merisi was known, like many Italian artists, by the name of his birth place, Caravaggio, a town in northern Italy. After a four-year apprenticeship in Milan he went to Rome and quickly began to establish a reputation. The stir Caravaggio caused in contemporary circles by his paintings was more than equalled by the interest his turbulent personal life aroused: but his temper sometimes got him into trouble. Eventually, in 1606, he killed a man and had to flee the city. For the rest of his life he lived and worked in Naples, Malta and Sicily. He died while on his way back to Rome at Porto Ercole shortly before his thirty-seventh birthday.

The Supper at Emmaus was painted shortly after Caravaggio had become famous in Rome. Here the religious subject is treated with appropriate seriousness and drama, aspects of Caravaggio's art that developed further to the dark, mysterious religious paintings of his later years. Christ (crucified only three days earlier), in blessing the food, passively reveals his identity to the two disciples who show their recognition with startled gestures.

Caravaggio has taken great care to emphasize the psychological drama of the event, using his by now mature control of his chosen techniques. The face of the mystified innkeeper remains in darkness, turned away from the light on the left. This same light illuminates the head and hand of Christ, still absorbed in the act of blessing the food. The disciple on the right registers his astonishment with a gesture that includes us; his outstretched arm balancing Christ's blessing. The different attitudes expressed by the disciples, Christ and the innkeeper combine to create a moment of beautifully staged, highly charged drama. The superbly painted basket of fruit, teetering on the table's edge, brings the tension of this apparently simple scene to an almost unbearable pitch.

Although Caravaggio's art is naturalistic, showing, for example, the disciples to be ordinary people, and events to be understandable to the visual 'vocabulary' of the man in the street, his paintings were often misunderstood and shunned by people and clergy alike. Yet the clarity of his renderings of religious subjects embodied much of what the Counter Reformation was trying to achieve in the visual arts. It is not surprising, then, that this picture was in the collection of Cardinal Scipione Borghese (it may even have been commissioned by him), the person who first noticed the genius of the young Bernini and one of the greatest patrons of seventeenth-century art.

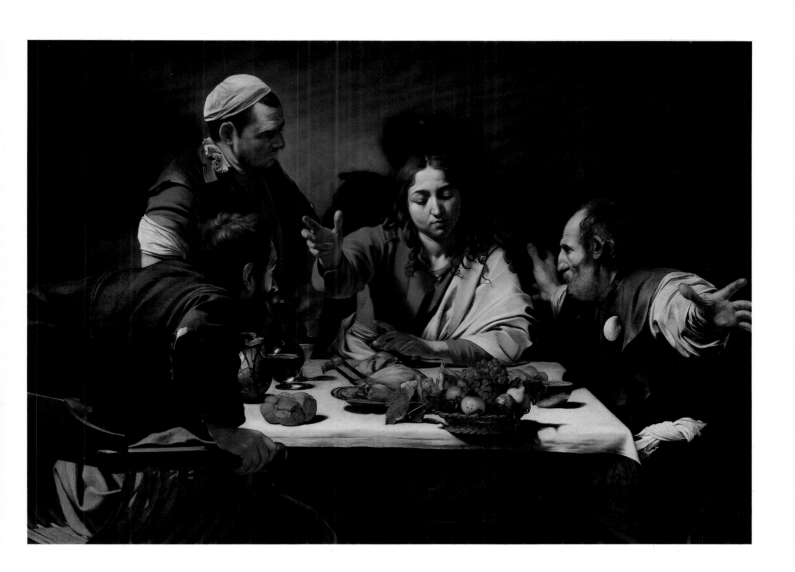

PLATE 21

Annibale Carracci, 1560–1609

Christ appearing to St Peter on the Appian Way (No. 9)
['Domine Quo Vadis?']

Panel 77.4 × 56.3 cms.
Purchased 1826

Like Caravaggio, Annibale Carracci had many followers and his work was of fundamental importance for Italian Baroque painting. But unlike his idiosyncratic contemporary Annibale's own training and that of his followers was based on formal, academic traditions. Annibale was the greatest of the Carracci family, the founders of an academy of painting in the city of Bologna in 1585. His work draws freely on a variety of influences: Raphael, Correggio and the great sixteenth-century Venetian painters. In spite of this profusion of sources Annibale's paintings are always clearly recognizable with their skilful draughtsmanship and strong colours. While the intellectually and visually complex Mannerist painting of the late sixteenth century could hardly represent the Counter Reformation's edicts on art, Annibale's pictures are exemplary in their clarity. In this respect his work is similar to that of Caravaggio, which is one of the reasons why both painters were crucial to the development of seventeenth-century painting. ·

Annibale left Bologna for Rome in 1595 and soon began decorating the great gallery in the Palazzo Farnese. The gallery, finished around 1604, was once considered alongside the work of Raphael and Michelangelo in the Vatican as one of the essential sights of Rome. After this Annibale's success was assured, although in the last years of his life he suffered from both mental and physical illness.

Painted around 1600, 'Domine Quo Vadis?' (Master, where are you going?) is an unusual subject. As in many seventeenth-century depictions of St Peter, it emphasizes the humanity of the founder of the Church of Rome. As Peter left the city along the Appian Way, fleeing from Nero's persecution of the Christians, he met Christ carrying the Cross. Peter asked him where he was going: Christ replied that he was going to Rome in order to be crucified a second time. Spurred by his master's example Peter returned to Rome where he too was eventually crucified.

The superb, confident drawing of Christ's body is a result of diligent study not only of Old Masters such as Raphael but also, as surviving drawings show, from live models. The colouring and lighting are bright and frank, the antithesis of Caravaggio's mysterious effects of light and shadow. The background of 'Domine Quo Vadis?' shows a sensitively painted landscape with classical buildings. Annibale's landscape painting is sometimes neglected, but this was an important aspect of his art and also highly influential on the next generation of painters.

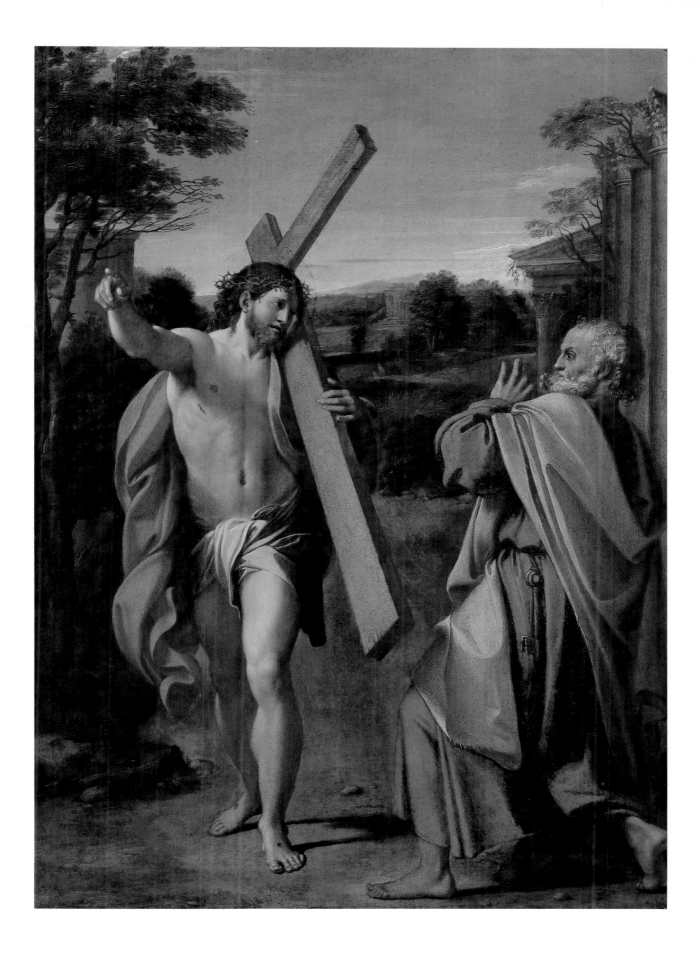

PLATE 22

Annibale Carracci, 1560–1609

The Dead Christ Mourned (No. 2923)
['The Three Maries']

Canvas, 92.8 × 103.2 cms.
Presented by Rosalind, Countess of Carlisle 1913

Unlike the preceding painting, 'Domine Quo Vadis?' this subject – the *Pietà* – had long been common in European painting. The theme is immediately familiar to us and would have been to people in the seventeenth century. Perhaps this was why Annibale felt he could vary the usual iconography by not including any men. Instead he shows Christ supported in his mother's lap with Mary Magdelen on the right. The two women behind are probably Mary Salome and Mary, the mother of James, both of whom were connected with the Passion in St Mark's Gospel.

This variation of the usual representation of the *Pietà* has allowed Annibale to intensify the emotional content of the scene. The fact that the mourners are all women makes the scene more intimate and their grief less restrained. This intensity of feeling is emphasized by the Virgin, who has swooned and collapsed into a position that repeats that of her Son.

Annibale has taken the main part of this composition, the group of Christ and his mother, from a picture of the same subject by Correggio in Parma. Correggio was one of the main influences on Annibale and the Carracci academy in Bologna.

But if in its intense feeling this picture differs from that of 'Domine Quo Vadis?' the paintings have many features in common. The brilliant colours, here even brighter than in the earlier work, allow Christ's dead body to stand out starkly. The complicated position in which he lies shows Annibale's competence as a draughtsman, able to handle the foreshortening of the legs and forearm without detracting from the convincing impression of the body's deadweight. But in spite of his academic training and instinctive Baroque feeling for presenting subjects as clearly as possible, Annibale Carracci's painting was never pedantic.

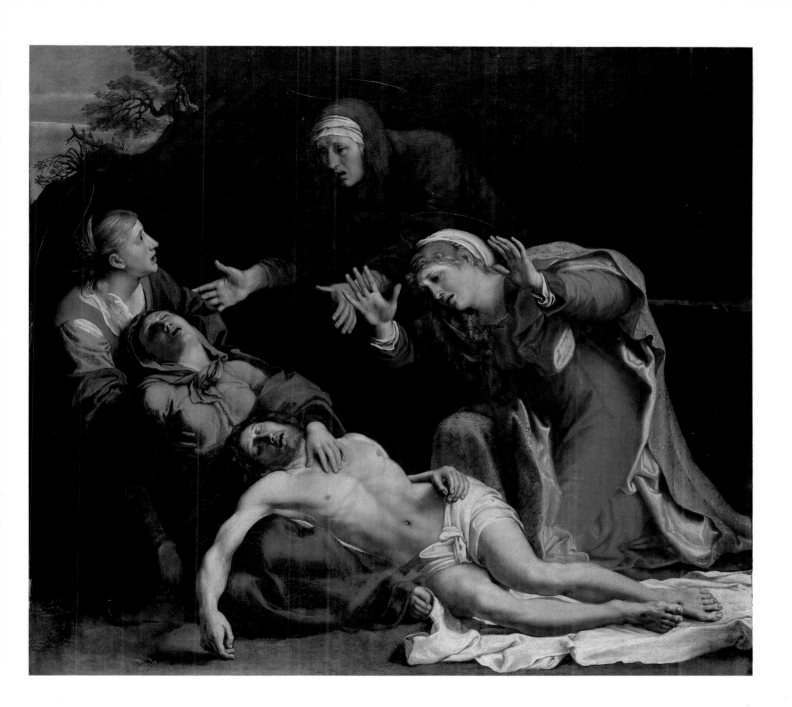

PLATE 23

Guido Reni, 1575–1642

The Coronation of the Virgin (No. 214)

Copper, 66.6 × 48.8 cms.
Bequeathed by William Wells 1847

Like other Bolognese artists of his generation Reni worked in various Italian cities, especially Rome. But his early training was in the academy of the Carracci in Bologna and it was in Bologna that he eventually settled. Although his academic training formed the basis of his work he was a versatile artist and once, in Rome, painted a *Crucifixion of St Peter* (now in the Vatican) in the manner of Caravaggio, proving that he was able to paint in that way although this was not his usual style.

Reni used techniques he learnt from the Carracci and developed them into a style that, while remaining recognizably Bolognese, became just as recognizably his own.

In this small *Coronation of the Virgin* the superb quality of Reni's draughtsmanship is immediately apparent. The composition is elaborate and full but uncluttered: the two large angels at the bottom go together with the Virgin in forming a triangle, a standard compositional device developed in the Renaissance. Using this clear formula Reni has fitted the many angels and *putti* into the picture without jeopardizing its clarity.

Reni's colouring, like Annibale Carracci's, is bright: but in the *Coronation of the Virgin* one can see how much more subtle is Reni's work in this respect. The beautiful fabrics of the drapery, the shot silks of the angels' robes and the rich blue of the Virgin's mantle show Reni's ability to create interesting and varied textures.

By painting on the smooth surface of copper Reni was able to achieve a fineness of detail that would have been impossible on canvas. The angels' faces and instruments are all clearly defined (except where they recede into the golden light, creating an illusion of space). One can even make out the notes of music which the charming little *putti* beneath the Virgin are singing. The intimacy Reni achieves contrasts with the grand subject of the picture.

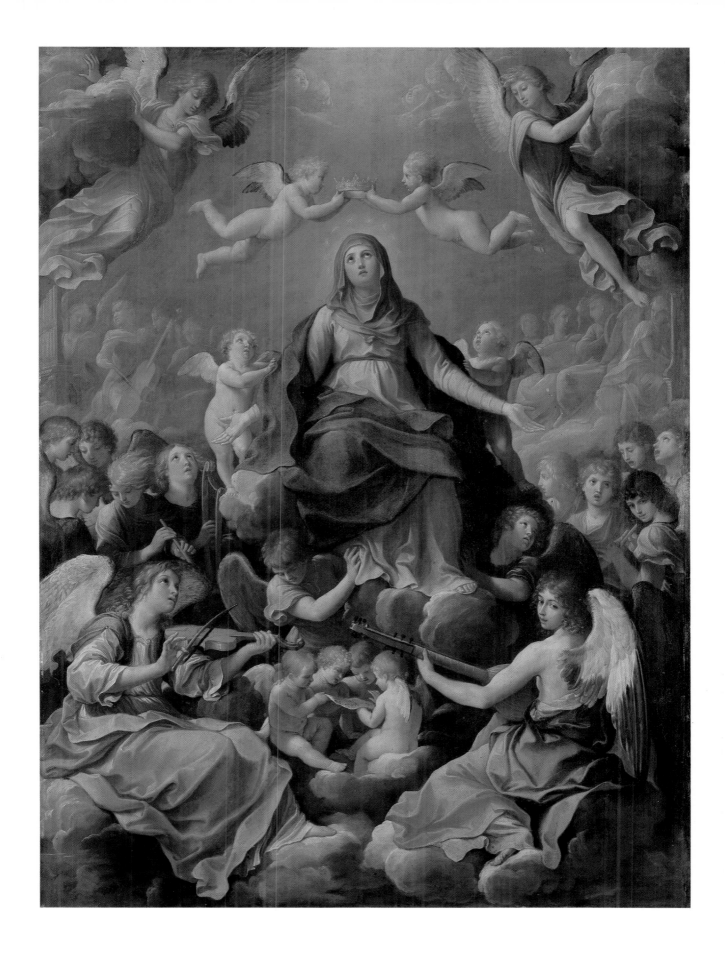

PLATE 24

Domenico Zampieri, *called* Domenichino, 1581–1641

Landscape with Tobias laying hold of the Fish

(No. 48)

Copper, 45.1 × 33.9 cms.
Holwell Carr Bequest 1831

Domenico Zampieri, nicknamed Domenichino on account of his diminutive stature, was one of Annibale Carracci's most important assistants and became one of the leading Baroque painters of his day. Like Reni's his art is based firmly on the Bolognese style: but Domenichino developed his own recognizable manner within the guidelines of the Carracci academy.

Many of Domenichino's most important commissions were for cycles of fresco decorations either for churches or for the palaces and villas of wealthy cardinals and noblemen. (The National Gallery has eight frescoes painted for the Villa Aldobrandini at Frascati, near Rome.) Although he was from Bologna he worked mainly in and around Rome: he was also active in Naples where, cruelly persecuted by local artists, he died.

The subject of Tobias and the Angel occupies only a small part of the picture. Tobias, on an errand for his blind father, is attacked by a fish from the River Tigris (Domenichino has given the fish teeth). The archangel Raphael, accompanying Tobias on his journey, instructs him to take hold of the fish and gut it. They roast the fish and the archangel tells Tobias that by burning the liver and heart he can produce a smoke that will drive away the devil (which Tobias eventually does on his wedding night) and that the gall of the fish will cure his father's blindness.

Even more than his master Annibale Carracci Domenichino used landscape as an integral part of his paintings. The main theme of this picture is the extensive landscape, framed by trees, with the river winding away into the distance. On a rocky outcrop sits a fortified castle, possibly part of a town. In the far distance one can just make out tiny towns with white buildings. Behind the hills the faint glow of the sun appears, penetrating the lowest leaves of the tree on the left. The lyrical feeling of such paintings impressed the great Frenchmen, Claude and Poussin, who worked in Rome: their own works, later so crucial to the development of landscape painting in England, have a common source in the art of Domenichino.

PLATE 25

Giovanni Francesco Barbieri, *called* Guercino, 1591–1666

Angels weeping over the Dead Christ (No. 22)

Copper, 36.8 × 44.4 cms.
Holwell Carr Bequest 1831

It seems that Guercino was, for the most part, self-taught, but his native town, Cento, which had no real tradition of painting, is close to Bologna and the young Guercino inevitably came under the influence of the famous Carracci academy. The artist had a squint, *guercino* in Italian, hence his nickname. Unlike many artists who develop a more individual style as they grow older, Guercino's early manner was already highly developed and original. After visiting Rome in 1620 (he stayed for three years), and settling in Bologna in 1644, his work became more generalized and moved towards the classical manner of the Carracci and Guido Reni. After the latter's death in 1642 Guercino's style had altered sufficiently for him to replace Reni as leading painter in Bologna, catering for the tastes of Bolognese patrons.

This picture is an early work, dating from around 1618 when Guercino was a mature artist but still painting in a highly original way. Most striking are the richness of the colouring and the softened outlines of the forms. Although he was one of the greatest draughtsmen of the seven-teenth century, Guercino mainly used colour to model form in his paintings. This implies that he had some knowledge of sixteenth-century Venetian painting where such effects were usual. Velázquez, who also studied the great Venetian painters, is known to have admired Guercino.

Guercino used not only colour, but also light and shadow to model form in his pictures rather more than his Bolognese contemporaries. Caravaggio's influence has been suggested but, although they can sometimes be dramatic, Guercino's paintings are much less intense than works by Caravaggio. He may again have looked to the Venetians to learn these effects, and possibly to Correggio.

Unlike Annibale Carracci's 'The Three Maries', where the mourners wail their grief, Guercino's Christ is silently mourned by the two angels. The picture is small and intimate, designed for quiet devotion and contemplation. Although the colours are deliberately subdued Guercino manages to keep them rich and saturated. And though Guercino avoids drama he still manages to convey the deep grief of those who mourn.

PLATE 26

Giovanni Francesco Barbieri, *called* Guercino, 1591–1666

The Incredulity of St Thomas (No. 3216)

Canvas, 115.6 × 142.5 cms.
Purchased 1917

Painted in early 1621 for Bartolomeo Fabri, a native of Guercino's own town of Cento, *The Incredulity of St Thomas* is one of a pair; the other, *The Betrayal of Christ*, is now in the Fitzwilliam Museum, Cambridge.

The story is told in St John's Gospel. Thomas had not been present when the newly resurrected Christ revealed himself to the disciples. When the disciples told Thomas the news he refused to believe it until he had himself touched Christ's wounds. Eight days later Christ appeared and instructed Thomas to put his hand into the wound, after which the disciple was convinced.

In Guercino's painting Thomas is completely absorbed in touching the wound: he is shown at the moment when his doubt is giving way to belief in the Resurrection. Christ looks down benevolently, but not condescendingly, at the tousled head, aware that Thomas' faith, though it may need encouragement, is firm.

While the head and torso of Christ are brilliantly illuminated, the face of Thomas in his disbelief remains in darkness. Although the light effects are more striking than in *Angels weeping over the Dead Christ* this picture still lacks the contrived intensity of Caravaggio's work. The light in *The Incredulity of St Thomas* reinforces rather than merely exposes the meaning of the picture.

In much of his earlier work Guercino concentrated on the use of hands as an important link across a composition. Christ's hand, drawing back his rich blue robe to reveal the wound where the spear had pierced his side, is made especially prominent by the other hands in the picture, which all occupy a different plane: by this gesture Christ's outstretched arm invites us, too, to view the wound and, like Thomas, to believe.

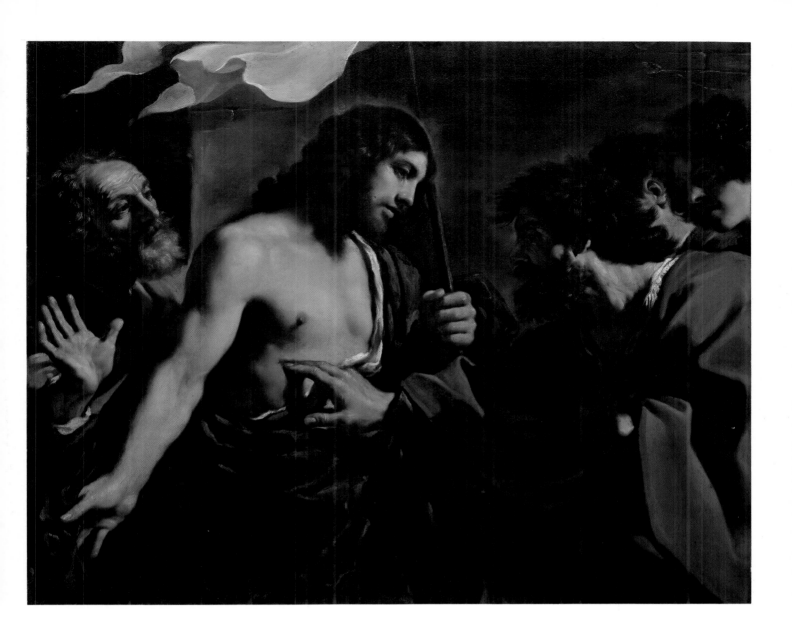

PLATE 27

Carlo Saraceni, 1589–1620

Jacob reproaching Laban for giving him Leah in place of Rachel (No. 6446)

Copper, 28.5 × 35.3 cms.
Bequeathed by Benedict Nicolson 1978

Saraceni does not conveniently fall in with any particular group of artists or style of painting. He was born in Venice and died there at the age of thirty-one but spent most of his working life in Rome, where there were two main influences on his art. Like many artists of his generation, he came under the spell of Caravaggio and many of his larger paintings reflect this. However, this painting shows the direct influence of a young German painter, Adam Elsheimer (1578–1610), who had worked in Venice but gone on to Rome in 1600 where he eventually died. Saraceni, who was in Rome before Elsheimer died, probably painted *Jacob reproaching Laban* around 1610.

Like much of Elsheimer's work (there are several of his rare paintings in the National Gallery) this picture is small and on copper, which gives a smooth surface and allows the artist to work in minute detail. The individual brushstrokes are fine, creating a jewel-like quality. Elsheimer made especial use of this technique in his exquisite landscapes, which were so much admired by Rubens (who also knew Elsheimer in Rome), and they specifically influenced Saraceni in painting the trees in the background of this picture.

The story of Jacob was a popular one (see Ribera's *Jacob with the Flock of Laban*, plate 9) but paintings of this particular episode are rare. (There is one by the Dutch artist Terbrugghen in the National Gallery.) Jacob had worked for his uncle Laban for seven years in order to earn the hand of his beautiful daughter, Rachel. But on the wedding night Laban substituted his other daughter, Leah for Rachel. In the morning, realizing this deceit, Jacob reproached Laban who replied that it was customary for the elder daughter to marry first. Jacob worked for a further seven years before he was permitted to take Rachel as a wife.

In Saraceni's picture Jacob, anguished, clutches Laban's arm pointing angrily to Leah who, understandably, seems upset by Jacob's reaction. (Later, when Rachel also became Jacob's wife, there was great rivalry between the two sisters.) It is probably Rachel, grieving at not becoming Jacob's wife, who stands behind the two men. The enormous well on the left alludes to the first meeting between Jacob and Rachel when he helped her water her father's sheep. This meeting, a joyful subject, was often illustrated by painters: Saraceni's picture, on the other hand, represents one of the less happy episodes in the story, showing a scene fraught with deception, rejection and guilt.

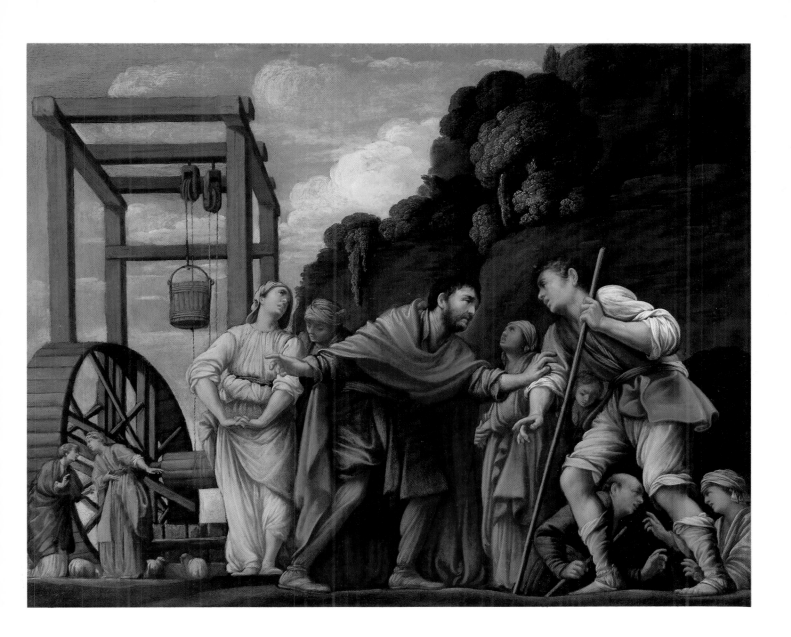

PLATE 28

Roman School, seventeenth century

St Cecilia (No. 5284)

Canvas, 143.5 × 108.9 cms.
Purchased 1941

During the 1620s art in Rome had not yet recovered from the effects of the very different styles of Annibale Carracci and Caravaggio, both of whom were dead by 1610. Yet in spite of the excitement caused by Caravaggio's work it was Annibale's paintings that became more important as a basis for High Baroque painting in Rome. This was largely due to the fact that Annibale had many students (Domenichino, Lanfranco etc.) and followers who perpetuated his more traditional academic methods. Caravaggio's 'followers' were not organized in any way, were often foreign and sometimes painted only a few specifically 'Caravaggesque' pictures.

This picture, here simply attributed to the seventeenth-century Roman School, is possibly an early work by Pietro da Cortona, the most important High Baroque painter in Rome; he was also an extremely fine architect. But for the purposes of this book the importance of the picture lies in its showing how seventeenth-century painting in Rome began to 'settle down' into a recognizably Roman Baroque style after the turmoil of the beginning of the century.

The bright colours, rich drapery and ornament, combined with the solidity of the main figure in this picture, are all characteristics that were to continue throughout the seventeenth century in Roman painting. Pietro da Cortona himself had many followers; they painted altarpieces, small devotional pictures and, above all, elaborate ceiling decorations in palaces and churches all in a style based on his. Later in the century Luca Giordano (see plate 34) was to form a link between this Baroque flamboyance and the lighter, more decorative styles of the eighteenth century.

St Cecilia was an especially popular saint in Rome. A third century Christian virgin martyr, her tomb had been reopened in 1599 and her body was found to be perfectly preserved (although it disintegrated immediately). Her remains were reburied in the church in Trastevere where she had previously been interred around 820. The discovery of her body gave impetus to a revival of her cult. St Cecilia is also the patron saint of music, which added to her popularity: at her wedding she had persuaded her new husband to take a vow of chastity and become a Christian; during the wedding ceremony she had sung 'in her heart' to the Lord. This kind of inner prayer had a relevant modern parallel in the spiritual exercises of the Jesuits.

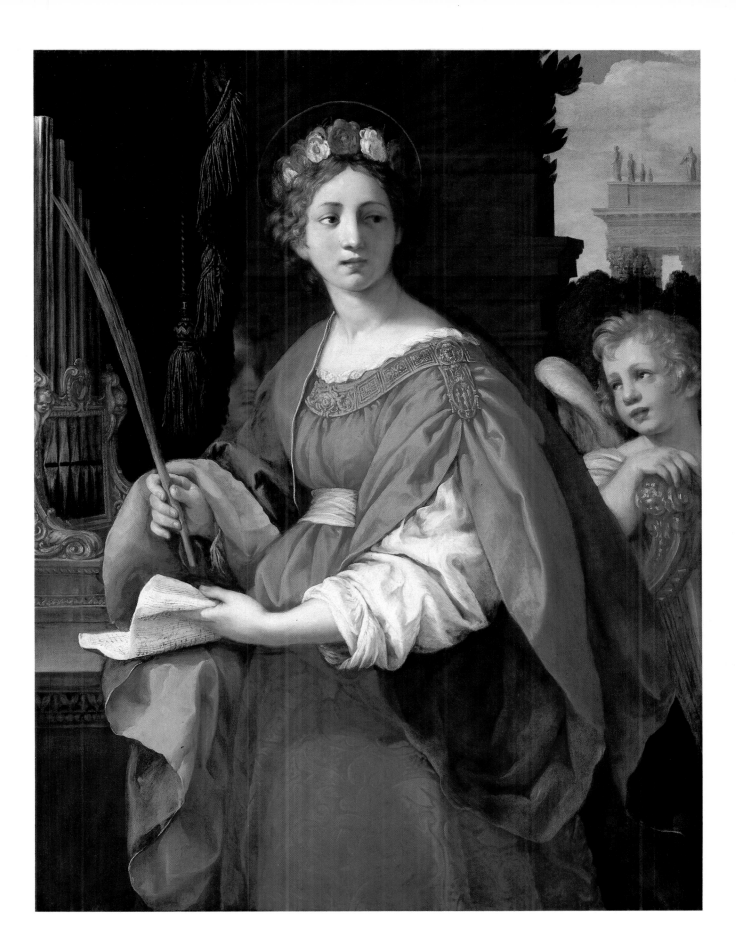

PLATE 29

Giovanni Battista Salvi, *called* Sassoferrato, 1690–1685

The Virgin in Prayer (No. 200)

Canvas, 73.0 × 57.7 cms.
Bequeathed by Richard Simmons 1846

The Pre-Raphaelites and the German Nazarenes were by no means the first to use the work of Raphael as the foundation for their art. At the beginning of the seventeenth century the Carracci had looked to Raphael for the cool discipline of his draughtsmanship. Guido Reni's paintings, especially the early ones, reflect considerable study of Raphael. Giovanni Battista Salvi, known as Sassoferrato after his birthplace, was especially influenced by Raphael as well as by contemporary painters like Guido Reni, from whom he even directly copied certain compositions.

Sassoferrato's own compositions often lack originality, and when he created a successful picture he or his studio assistants would make several versions of it. This small, devotional picture of *The Virgin in Prayer* was one of his most popular. There are well over a dozen versions and copies by Sassoferrato himself, of which this is among the finest. In spite of his reliance on other artists in many of his works,

Sassoferrato was a superb technician. His highly competent draughtsmanship is more than matched by his skills of applying the paint to the canvas. His pictures are usually finished to a very high standard in a range of simple but brilliant colours.

The National Gallery has two pictures by Sassoferrato, both of which were acquired in the mid-nineteenth century. In both Sassoferrato has used the dazzling ultramarine for the Virgin's robe that is so striking in this picture. This brilliance evidently proved to be too much for Victorian taste, accustomed as it was to paintings covered with yellow varnish. These pictures were actually toned down with tinted varnish so as not to offend genteel taste. Recently this and the other painting by Sassoferrato in the National Gallery (*The Virgin and Child embracing*) have been cleaned, revealing the brilliant colouring that the artist originally intended.

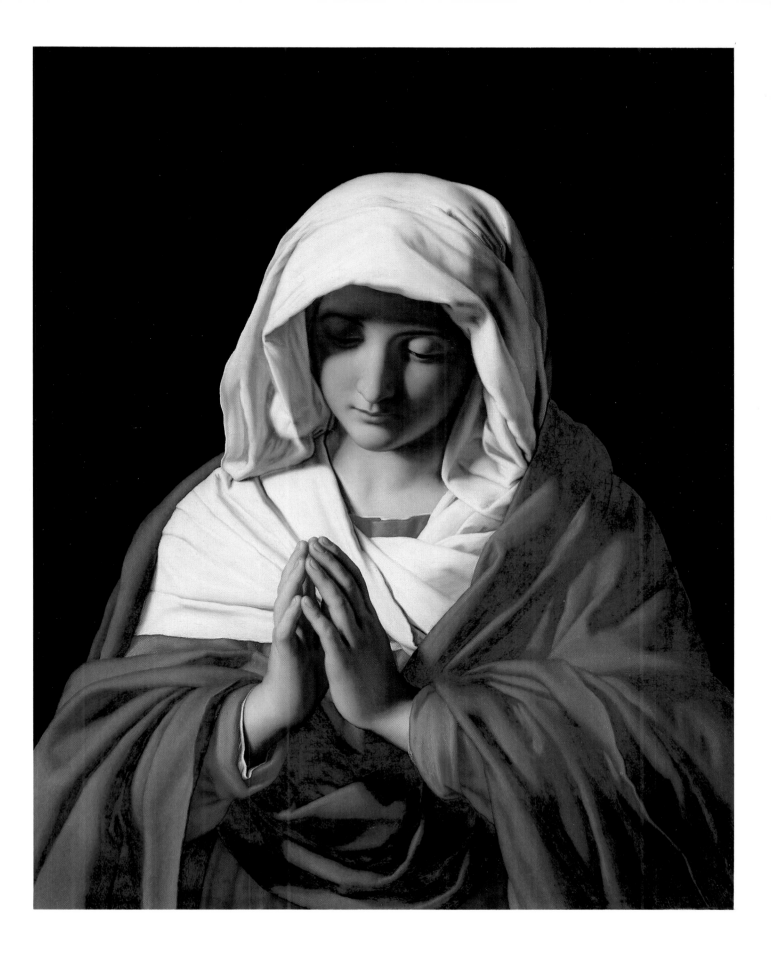

PLATE 30

Bernardo Strozzi, 1581–1644

A Personification of Fame (No. 6321)

Canvas, 106.7 × 151.7 cms.
Purchased 1961

Venetian painting of the seventeenth century is little known compared to the great art of the sixteenth century when Bellini, Giorgione, Titian, Veronese and Tintoretto painted there. Although native talent in the seventeenth century was fairly sparse (the political and economic power of the Republic had also declined) the quality and quantity of art already in the city, along with the intellectual attractions and the sheer beauty of Venice, lured many artists, not only from other Italian towns but from abroad as well.

Bernardo Strozzi, from Genoa, was a Capuchin friar who left his native city and had settled in Venice by 1631. He had been allowed to leave the Capuchin order many years earlier in order to care for his mother: but he remained a priest, earning the nickname *il prete genovese*. No single Venetian painter had a specific influence on Strozzi's art but he must have found stimulating the many varied technical innovations the Venetians had made. His own technique is unusual. In order to achieve a variety of textures across the golden robe in this picture he used fairly thick paint, sometimes in tight controlled squiggles (a highlight over Fame's left knee) or in loose formless brushwork (the triple band of the robe). His method of painting flesh is also distinctive, with warm rosy highlights applied over a cool blue ground.

Most of all it is in the brilliant richness of the colouring that Strozzi's picture shows the influence of Venetian painting. The blue of her drape and the red of her bodice make Fame's heavy yellow robe stand out and appear gold. The Venetians have always been known for their ability as colourists and, again, it was from the general body of Venetian art, rather than a particular painter, that Strozzi drew his inspiration.

The idea of personifying Fame dates back to classical antiquity, where she is shown without trumpets: these began to appear during the Renaissance. The two instruments in this picture may symbolize good and bad fame, but it is not clear which is which. Although Fame's wings are supposed never to tire Strozzi has made her a very casual, inviting figure reclining against a rock: this attitude is enhanced by the sense of uncertainty about whether she has just sounded, or is about to sound, the trumpet in her left hand.

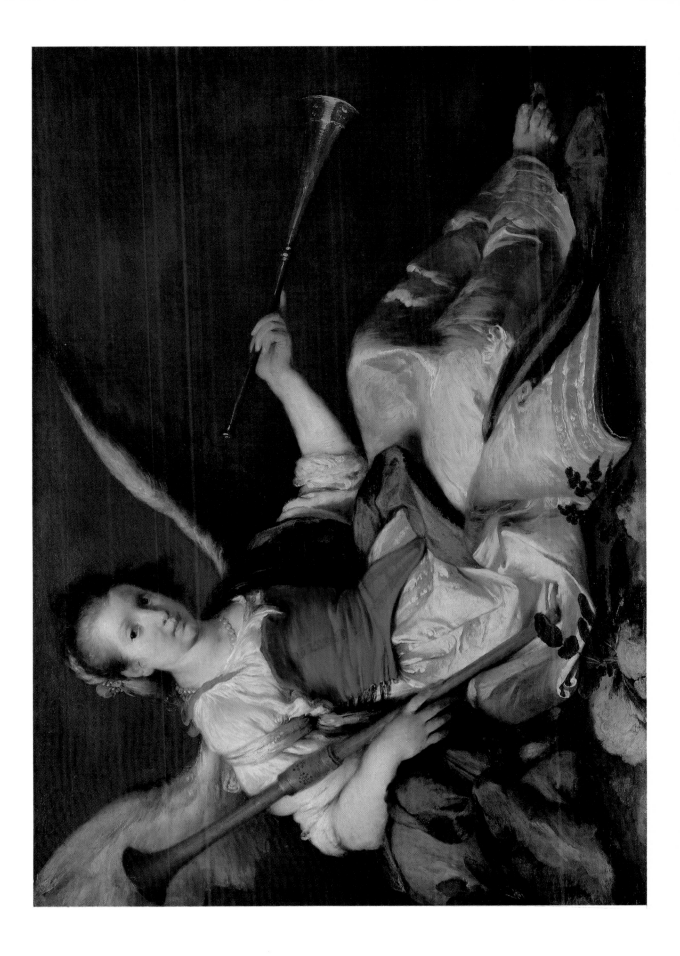

PLATE 31

Salvator Rosa, 1615–1673

Self-Portrait (No. 4680)

Canvas, 116.3 × 94.0 cms.
Presented in memory of his father by the 6th Marquess of
Lansdowne 1933

In the eyes of the British Rosa's character, or imagined character, has often held more interest than his paintings. Yet it is partly from his paintings, his 'savage' landscapes, that the British, especially in the eighteenth century, derived their fanciful image of the bandit and criminal. The appearance of this self-portrait does little to dispel that image.

Rosa was not only a painter: he was also an actor and a writer of verse and satire. He regarded himself as a leading intellectual and philosopher and it is true that he led an intellectually aggressive, highly active life, making plenty of enemies in Rome and Florence. But, no matter what British people like to believe, he was not brought up by bandits and in fact probably had a fairly conventional training.

Until the age of twenty he lived and worked in Naples, gaining a reputation as a painter of talent. He moved to Rome and, after revisiting Naples at the age of twenty-two, never returned to his birthplace: later he even vilified Naples in a satirical verse. In Rome he led a flamboyant life, no doubt earning a living by painting, but spending time on the streets and acting. Finally, by 1640 his outspoken criticism and personal attacks on leading figures and institutions, including even Bernini, made him extremely unpopular. He moved to Florence, where he led a comparatively calm, but still active existence.

This self-portrait was probably painted around the time he left Rome. There exists a companion picture of Lucrezia, Rosa's lifelong mistress, whom he met soon after his arrival in Florence. He presents a stark image of himself; serious, even sneering and dressed simply – but with the cap of a scholar. The Latin inscription reads 'Be silent unless what you have to say is better than silence'. The severe aspect and inscription of this portrait reflect Rosa's interest in the Stoics, whose philosophy was fashionable with several seventeenth-century painters including Ribera and Poussin.

Ribera's work was important for Rosa: in spite of his peripatetic nature his art remained rooted in Naples. Ribera's single figures of philosophers in ragged clothes appealed not only to Rosa's stoical outlook: their monumentality evidently seemed appropriate for portraying himself.

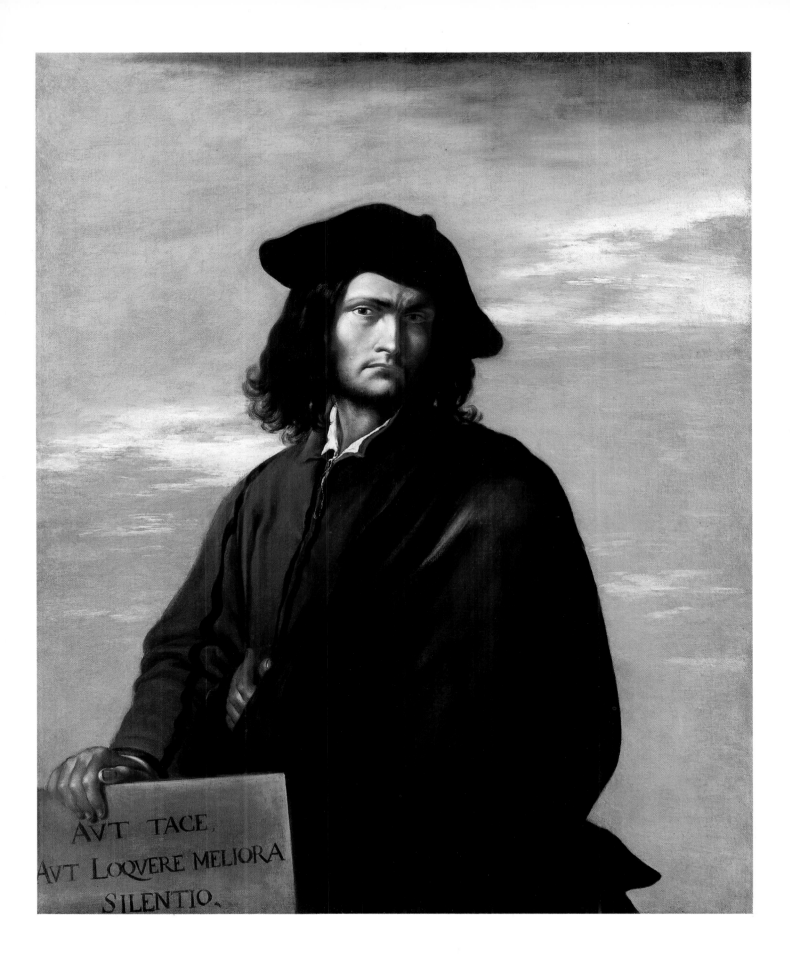

PLATE 32

Salvator Rosa, 1615–1673

Landscape with Mercury and the Dishonest Woodman (No. 84)

Canvas, 125.7 × 202.1 cms.
Purchased 1837

It was Rosa's landscape paintings, rather than portraits or battle and witchcraft scenes, that achieved tremendous popularity for the artist in eighteenth-century England. The characteristic that appealed most was the wild 'savage' atmosphere of the scenery which was regarded as 'sublime'. There were great debates in eighteenth-century artistic circles designed to categorize qualities that made paintings, especially landscapes, 'picturesque', 'beautiful', or 'sublime'. Burke maintained that 'astonishment' and 'fear' were the essential qualities of the sublime. (This was later ridiculed by Richard Payne Knight who wrote that the sight of Burke walking down St James's Street without his breeches, holding a loaded blunderbuss, would cause both astonishment and terror – but would hardly be sublime.) The landscape paintings of Salvator Rosa became central to this debate.

This is exactly the sort of painting that excited genteel eighteenth-century taste: the excitement was generally an experience of the drawing room derived from images safely on the canvas. But certain travellers would go out in search of such landscapes in the Welsh mountains, or even the Alps. Others would create wild areas in their gardens, building waterfalls and grottoes, the latter in more eccentric cases being equipped with a live hermit!

The subject of this picture, which probably dates from the 1650s, is taken from Aesop's Fables and has a moral, in keeping with Rosa's impression of himself as one of the intellectual and moral leaders of the age. A woodman lost his axe in the river and Mercury asked if it was made of precious metal. The woodman replied that it was not and Mercury rewarded him for his honesty with an axe of gold. Seeing this a dishonest woodman claimed he had lost a golden axe: Mercury returned him an ordinary iron one.

The windswept trees, jagged broken trunks, the blustery sky and icy mountains on the horizon all create an impression of wild uninviting landscape. This is matched by the apparently rapid brushwork. But if the impression is wild Rosa's technique is in fact superbly controlled: two birds skimming across the water are mere flecks of white paint: and the light effects on the mountains are built up with many delicate, subtle colours reminiscent of landscapes by Cézanne.

PLATE 33

Mattia Preti, 1613–1699

The Marriage at Cana (No. 6372)

Canvas, 203.2 × 226.0 cms.
Purchased 1966

Although often grouped with the Neapolitans, Preti was a truly cosmopolitan painter. Like his near contemporary, Luca Giordano (see following page), who was from Naples, he travelled widely and came under the influence of many different painters both living and dead. It was artists like Preti and Giordano who set an example for many eighteenth-century painters who travelled not only throughout Italy but all over Europe. Preti, however, settled down on the island of Malta in 1660 where he remained for nearly forty years until his death. He was created a Knight of St John of Jerusalem in 1641.

Like many Baroque artists Preti was versatile as well as cosmopolitan: he worked in fresco and on canvas for ceilings (the church of S. Pietro in Maiella in Naples has a particularly fine series of ceiling canvases by Preti) and painted many alterpieces. But he favoured painting banquet scenes such as the Marriage at Cana, of which this example was painted shortly before 1660. Christ, seated at the right of the picture, is turning the water into wine: it was his first miracle. Preti has concentrated on portraying the reactions of those present. Those seated near Christ have already realized what has taken place. The woman on the left, her hair richly adorned with pearls, is turning her head to see what the excitement is about. Those at the far end of the table are as yet unaware of the miracle. Preti's presentation of the scene as a tangible event, happening to real people, is still in perfect accord with Counter Reformation ideas, even though the Council of Trent took place a hundred years before the picture was painted.

Like Tiepolo a century later Preti had looked to the work of Veronese, especially his feast scenes, for inspiration. The sheer variety of activities portrayed, and the almost casual manner of including details (the dog, for example) stem directly from Veronese's pictures. The daring composition with the abruptly foreshortened table plunging into the depth of the picture space can also be found in Venetian painting of the previous century, notably that of Tintoretto.

If Preti drew his ideas for the composition from sixteenth-century Venetian painting, the style of this picture is wholly contemporary. The bold lighting at first recalls the work of Caravaggio, especially his later Neapolitan paintings which Preti would have seen. But closer examination of *The Marriage at Cana* reveals the greater influence of Guercino (see plates 25 and 26). In Guercino's early works the whole surface of the picture forms a complex arrangement of light and shadow: Preti often copied this technique. In fact Preti is known to have met Guercino, whereas he was born three years after Caravaggio had died.

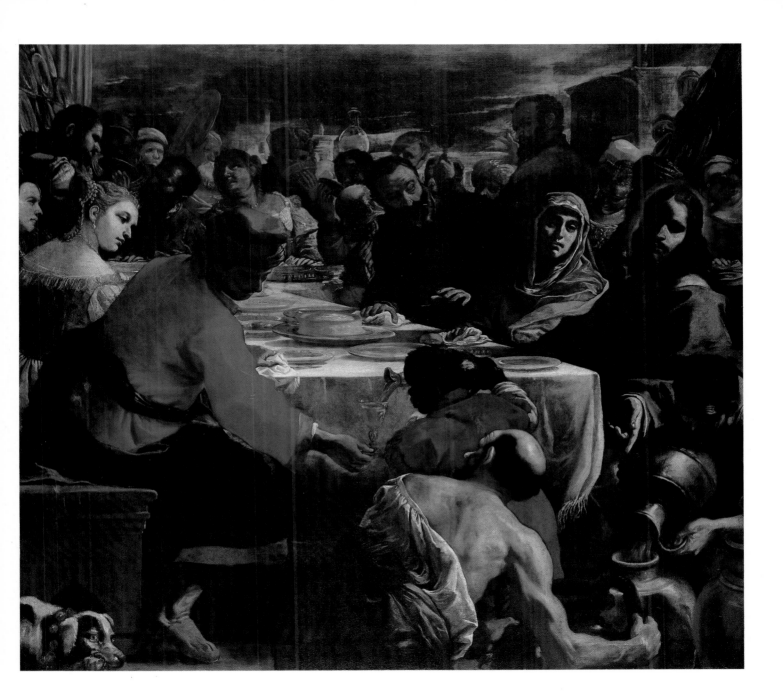

PLATE 34

Luca Giordano, 1634–1705

The Martyrdom of St Januarius (No. 6327)

Canvas, 106.7 × 80.6 cms.
Purchased 1962

Luca Giordano was one of the most cosmopolitan and prolific painters of the seventeenth century. He was from Naples but worked in Rome, Florence and Venice: he also spent ten years in Spain, working mainly in and around Madrid for King Charles II. He was as receptive to the styles of other artists as he was productive: and this assimilation of the work of various artists – Ribera, Veronese, Pietro da Cortona, even Veláz-quez – led to works that often differ greatly from each other. He seemed equally at ease producing vast decorative fresco cycles, painting altarpieces or small intimate pictures on copper. His immense versatility and energy was only to be matched in the eighteenth century by G. B. Tiepolo. The speed at which Giordano worked was legendary and earned him the nickname Luca '*Fa Presto*'.

The profusion of influences and styles in Giordano's work make it difficult to find a 'typical' example. His paintings are sometimes as smooth and highly finished as those by Reni, as realistic as works by Ribera or as flamboyant and bright as pictures by Pietro da Cortona. This painting falls into none of these categories. It is a sketch for an altarpiece in the church of S. Spirito dei Napoletani in Rome, possibly painted just before Giordano left for Spain in 1692. (Again the vast quantity and variety of Giordano's work often makes the precise dating of his paintings difficult.)

St Januarius is the patron saint of Naples: he was a Bishop of Benevento, martyred in the year 305. Several of his companions were also beheaded: their dismembered bodies can be seen on the left below the kneeling saint. In the finished altarpiece, which is proportionally taller and narrower than the sketch, the powerfully built executioner twists his body as he draws his sword, making him more dynamic than the executioner in this painting. But the angel in the final version is much less dramatic than the superb angel in this sketch: with great wings outstretched, pointing to Heaven with one hand, holding the saint's palm leaf, symbol of martyrdom, in the other, drapery billowing behind the beautifully poised leg, this angel dominates the picture. This may be the reason it was changed in the final version where, understandably, it is the saint who dominates.

If there is a factor common to all Giordano's work it is the fluency of his technique. This is, of course, especially obvious in a sketch. Giordano also created a brightness of tone that is noticeable even in this sombre-coloured picture. Both these factors were crucial for the development of European painting during the following century.

PLATE 35

Francesco Solimena, 1657–1747

Dido receiving Aeneas and Cupid disguised as Ascanius (No. 6397)

Canvas, 207.2 × 310.2 cms.
Purchased 1971

The story of Dido and Aeneas became popular in music and literature as well as in painting during the eighteenth century. It comes from Virgil's *Aeneid* (Book I) which Solimena would have been able to read in the original Latin; in fact his father, also a painter, had wanted young Francesco to study literature. Although he became a painter, Solimena was also an architect and was interested in poetry and music: he was a friend of Scarlatti.

Working mainly in Naples Solimena became the natural successor to Luca Giordano: he was prolific, worked in fresco as well as on canvas and made intelligent use of the art of his predecessors in order to develop his own. He went to Rome to study and copy paintings and, also like Giordano, worked for a while in Spain. Solimena's style of painting underwent several changes: the strong clear technique of this picture indicates a date in the 1720s when the artist was approaching the age of seventy (he was nearly ninety when he died). The figure on the right of the picture, wearing a Roman helmet, seems likely to be a self-portrait.

Solimena has read Virgil's story carefully. Aeneas and his men have been roaming for many years after the sack of their city, Troy (see G. D. Tiepolo's paintings, plates 44a and b). The Goddess Juno has been hindering his progress as much as possible. But Venus, the mother of Aeneas, wishes to protect him. Aeneas arrives on the shores of Carthage where Dido is Queen. Dido, who has been on good terms with Aeneas' enemy Juno, receives the Trojan traveller. To prevent Juno influencing Dido against her son Venus devises a plot: she disguises her other son, Cupid, as Ascanius, Aeneas' own son. When Dido greets and embraces the boy she believes to be Ascanius Cupid causes her to fall in love with Aeneas: not even Juno would have the power to influence her against him now. In fact Dido's love for Aeneas leads eventually to tragedy: when the hero leaves, later to found the race of Rome, Dido, in her grief, kills herself.

The picture shows the moment when Cupid approaches Dido. Both she and Aeneas believe the boy to be Ascanius: only we can see the wings that identify him as Cupid. Dido appears to be interested only in the boy, in spite of the crown and sceptre being offered by a negro on the left, or the glowing, golden robe, a precious gift which Aeneas himself indicates.

In spite of the richness and opulence of the colours and the luxurious, shimmering fabrics there is an air of classical grandeur in the picture. The main protagonists read simply across from Dido to the solid, almost sculpted kneeling figure who bears the lavish gift. This heavy frieze-like composition looks back to the seventeenth century rather than forward to the age of the Rococo and Tiepolo.

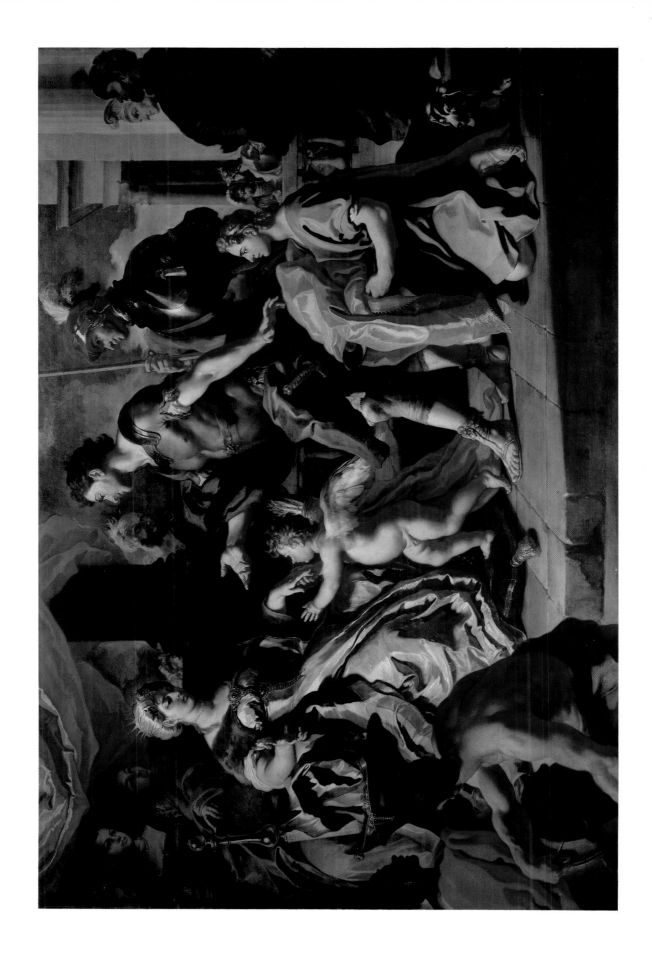

PLATE 36

Giovanni Battista Pittoni, 1687–1767

The Nativity with God the Father and the Holy Ghost (No. 6279)

Canvas, 222.7 × 153.5 cms.
Purchased with the assistance of the National Art-Collections Fund, the Noel Buxton Trust, and several donations 1958

In his own time Pittoni was regarded as one of the most important painters in Venice. He succeeded Tiepolo as president of the Academy in 1758 and enjoyed the patronage of foreigners, especially Germans, as well as Venetians. The Archbishop Elector of Cologne, who commissioned Tiepolo's *Vision of the Trinity appearing to St Clement* (plate 41), was a frequent patron of Pittoni.

Pittoni drew heavily on the work of many painters, mainly contemporary Venetians. Not unnaturally this resulted in a style that is recognizably Venetian, but it often lacks the depth or 'bite' of other eighteenth-century Venetian painters. However, Pittoni learnt his craft well and developed a highly competent technique which earned him considerable success.

There are certain aspects of this picture which owe much to a great eighteenth-century Venetian painter not properly represented in the National Gallery's collection: Giovanni Battista Piazzetta. The brilliance of lighting, unifying rather than fragmenting the picture, was a strong feature of Piazzetta's work: and the head of the Virgin in this painting is similar in technique, but not expression, to Piazzetta's renderings of female saints.

Painted around 1740 the picture is an altarpiece, although it is not known for which church it was commissioned. The Nativity was a popular subject, and to show St Joseph asleep was also fairly frequent. But it was rather unusual to show the Nativity combined with the Trinity. The earthly family itself forms a Trinity across the painting, complementing the Heavenly Trinity of God the Father, the Holy Ghost in the form of a dove, and the Infant Christ in the manger. Murillo had treated the subject of the Two Trinities independently some fifty years earlier (plate 13).

The picture was cleaned in 1959. Until then the upper part containing the heavenly Trinity had been concealed by overpainting dating from the nineteenth century, which emphasizes the fact that many people at that time would have found such a combination of subjects distasteful.

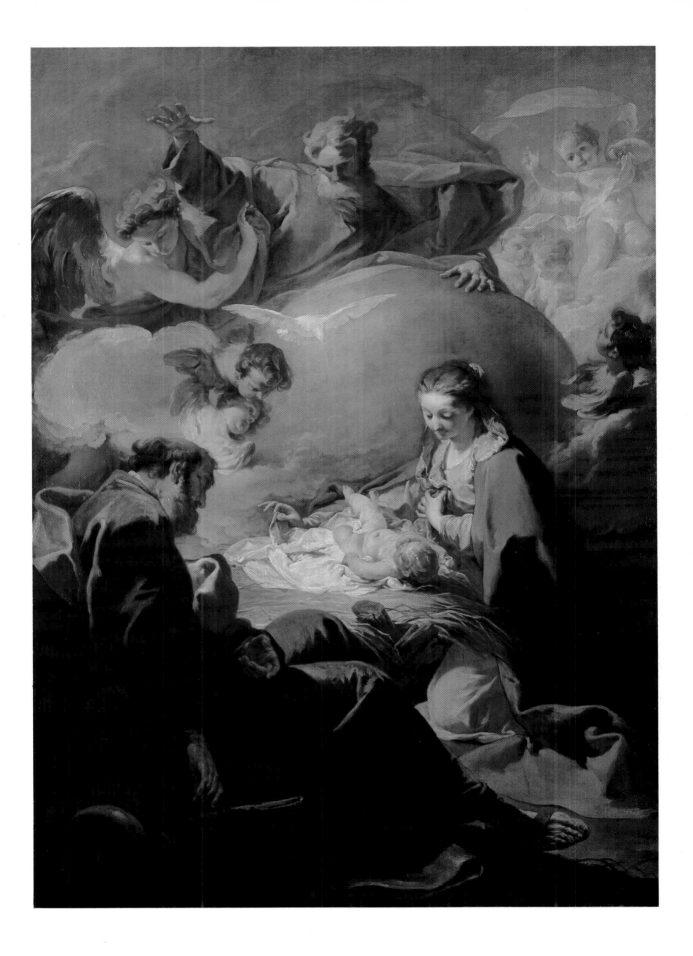

PLATE 37

Giovanni Antonio Pellegrini, 1675–1741

Rebecca at the Well (No. 6332)

Canvas, 127.3 × 104.5 cms.
Bequeathed by Claude D. Rotch 1962

At the beginning of the eighteenth century the reputation of Venetian painters was again growing. This was in part due to the willingness of the artists concerned to travel abroad. Painters such as Amigoni, Balestra and Sebastiano Ricci all worked for a time in foreign countries, including England. Pellegrini was the finest of these early eighteenth-century painters who travelled and he, too, spent several years in England as well as in Germany, France and the Low Countries.

This painting probably dates from Pellegrini's first stay in England, from 1708 to 1713. The subject, like that of Susannah and the Elders, was popular in Baroque painting partly because it enabled artists to paint the striking contrast between pretty, youthful girls and aged men with grizzly beards and dark skin. Pellegrini himself painted more than one version of *Rebecca at the Well*. The gentle drama of the moment allowed him to represent the scene in a correspondingly theatrical manner. (While in England Pellegrini collaborated in the painting of scenery for a production at the Haymarket theatre.)

The story of Rebecca at the well is from Genesis XXIV. Abraham sent his servant to search out a bride for his son, Isaac. Coming to a well the servant waited for a woman who would give both him and his camels water to drink. This was to be the Lord's sign that the woman was Isaac's future wife. When the beautiful Rebecca did exactly this the servant was overjoyed and immediately gave the surprised woman a bracelet, which she wears in this painting. The servant and his camels were then lodged with Rebecca's family who all agreed that she could, if she wished, become the wife of Isaac, which she duly did.

Pellegrini was known for the rapidity of his work. In this picture the brushstrokes are thick but fluently applied, especially in the draperies and Rebecca's pitcher. The contrast between the two main figures is almost as important as the subject itself. Pellegrini has cleverly engineered the composition so that this comparison becomes obvious: apart from the differently inclined heads the bodies of Rebecca and the servant face us, with their forearms in identical positions, one pale and delicate, the other sunburnt and swarthy. Profiled against the pink evening clouds the shaggy camels look on, impartial.

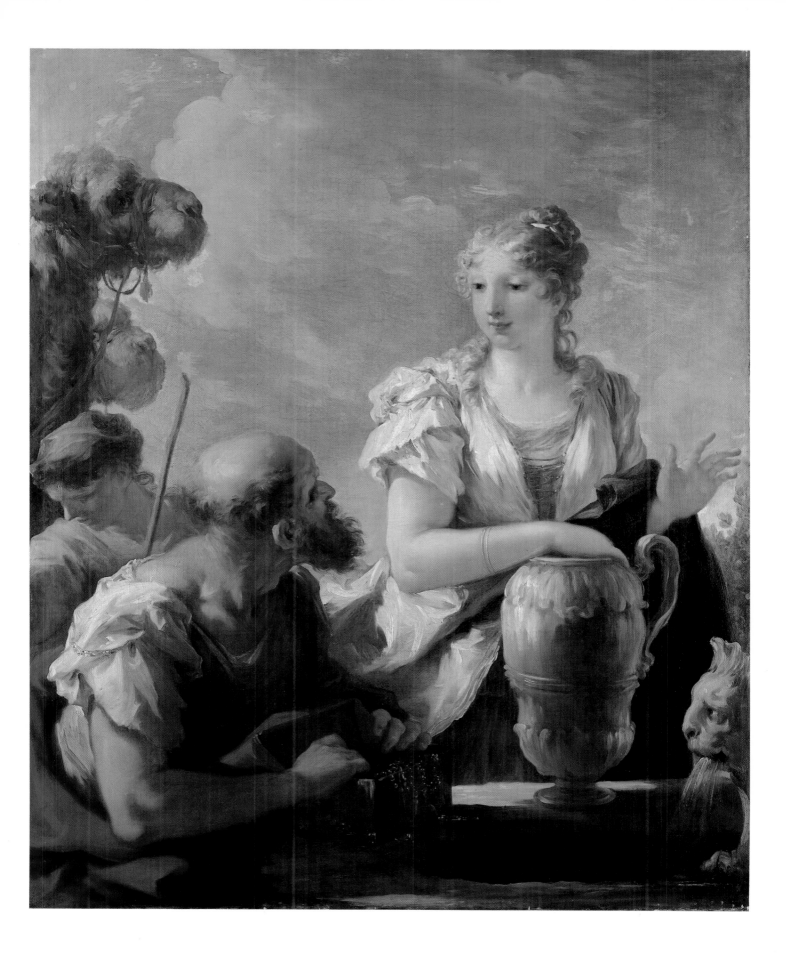

PLATE 38

Pietro Longhi, 1702–1785

Exhibition of a Rhinoceros at Venice (No. 1101)

Canvas, 60.4 × 47.0 cms.
Purchased 1881

In 1751 a rhinoceros was exhibited in Venice as part of the Carnival. Animals were frequently exhibited as attractions and the rhinoceros was one of the most exotic: few, if any, had been seen in Europe since the sixteenth century, when Dürer made his famous woodcut.

Longhi's pictures, most of them about the size of this one, invite us into the rarified world of the Venetian aristocracy of the eighteenth century. From the coffee houses and theatres to their stuffy parlours Longhi, in his awkward style, provides glimpses of the life behind the beautiful façades seen in Canaletto's paintings. He worked for many of the noble families of Venice: this picture has an inscription on the back recording that it was painted for Girolamo Mocenigo, a patrician and a member of one of the oldest families in the city. Longhi painted at least one other similar version of this picture for a member of the Grimani family. Even for such seasoned Carnival goers as the Venetians the spectacle of such a strange beast was exciting enough for them to commission paintings of it.

Most of the group of spectators look out at us, ignoring the rhinoceros. They seem to be posing for the artist, much as tourists today pose for cameras. But Longhi does not condemn this apparent vanity; he does not deliberately make these people appear empty. He merely records the scene.

The rhinoceros had been brought from Africa to Nuremburg in 1741, ten years before it arrived in Venice. The African rhinoceros usually has two horns, both of which have been removed from this animal: its keeper holds one of them. It was probably discovered at an early stage that a rhinoceros could severely wound a man with its horns. After several years of being exhibited around Europe this rhinoceros appears to be completely accustomed to its penned-in existence and phlegmatically munches its hay. Not even the Venetian onlookers, in their strange carnival masks, can perturb it.

PLATE 39

Nazario Nazari, 1724–after 1793)

Portrait of Andrea Tron (No. 1102)

Canvas, 249.6 × 165.9 cms.
Purchased 1881

This is the grandest type of portrait painted in Venice during the eighteenth century. It is of Andrea Tron (1712–1785), a member of one of the most important families in Venice. Tron is shown here as a senator, around 1770: in 1773 he was elected a Procurator of St Mark, a title which allowed him to wear a crimson stole instead of the one he wears in this picture. This heavy golden brocade is the Stola d'Oro, not a very high honour, frequently bestowed on ambassadors returning from duty abroad. Tron had been ambassador to Paris (1745–1748) and Vienna (1748–1751).

Nazari, the son of Bartolomeo Nazari who was also a portrait painter, was reasonably in demand in Venice, even painting a portrait of the Doge in 1763. Here he portrays Andrea Tron in a sympathetic, if old-fashioned, manner. His portly figure and large wig (out of date by 1770) give him a homely aspect. In spite of this the writing materials and simple but grand setting remind us that, as a senator, he still worked for the good of both people and state.

Although this is a large and, in its own way, slendid portrait it does not really bear comparison with Venetian portraiture of previous centuries, or even contemporary portraiture in England and France. But this is a true reflection of the relative unimportance of Venice as a political force in the eighteenth century. Less than thirty years after this portrait was painted the Republic of Venice, with all its elaborate but empty political protocol, was brought to an end.

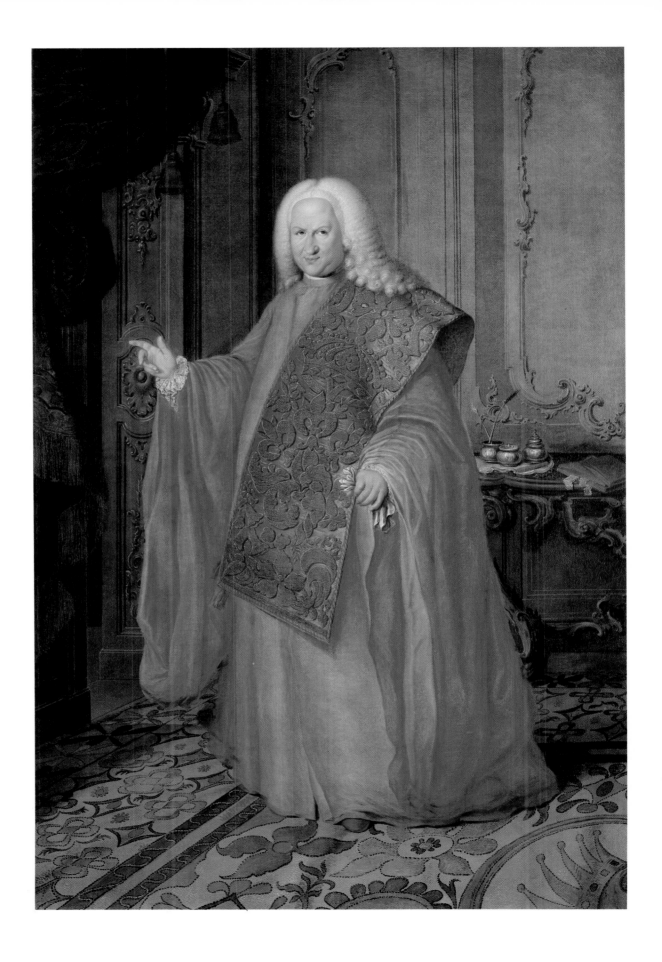

PLATE 40

Pompeo Girolamo Batoni, 1708–1787

Portrait of a Gentleman (No. 6459)

Canvas, 134.6 × 96.5 cms.
Purchased 1980

Batoni was the most sought-after portrait painter in Rome in the mid-eighteenth century and about half the portraits he made were of Englishmen. In fact his fame in his native Italy was due to 'history' paintings such as the National Gallery's *Allegory of Time ordering Old Age to destroy Beauty*. These paintings, like his portraits, are highly finished works that often took Batoni, as several patrons complained, months to complete.

The Grand Tour was regarded as an essential part of an aristocratic young Englishman's education. Venice and Rome were major stops and often the final destinations of the tourists. In Venice one acquired pictures by Canaletto; in Rome it was fashionable to have one's portrait painted by Batoni.

There are three portraits of this unknown gentleman by Batoni, one a miniature in the Fitzwilliam Museum, Cambridge. In this picture the sitter points to the word 'Grisons' on the map, perhaps implying that he had some particular interest in Switzerland but maybe simply to show that he was an experienced traveller. It became usual for Batoni to include some reference to the antique in his portraits. Many of the English travellers had, after all, gone to Rome to acquire first-hand knowledge of classical architecture and culture, and such visual references serve to remind us of the learning and education the sitter had gained from his being in Rome. There is rarely any false modesty in Batoni's portraits.

While some of the travellers decided to be portrayed in contrived costumes (for example, in the style of Van Dyck) this gentleman wears the fur-lined cape which happened to be fashionable among Italians around 1760 when this portrait was painted. This awareness of contemporary dress, revealed in the tight jacket and breeches, strengthens the impression that this was a sitter anxious to appear particularly dashing.

Although his portraits were popular among the Grand Tourists, Batoni's fame in this country plummeted after his death. Of course, most of the portraits were in the country homes of the aristocracy and not on view to the general public. But, more important, his reputation was overshadowed by the growing school of English portrait painting, dominated by Reynolds and Gainsborough.

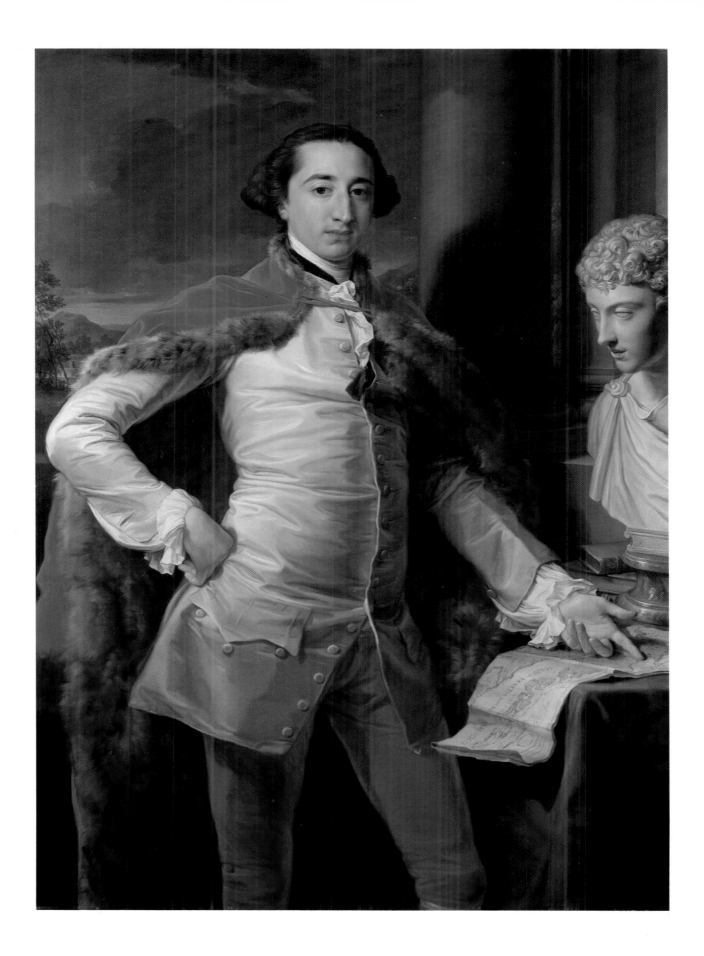

PLATE 41

Giovanni Battista Tiepolo, 1696–1770

A Vision of the Trinity appearing to Pope St Clement (?) (No. 6273)

Canvas, 69.2 × 55.2 cms.
Purchased with the aid of the National Art-Collections
Fund 1957

Giovanni Battista Tiepolo was the greatest Italian painter of the eighteenth century and perhaps the last great Italian artist. Venice, Tiepolo's birthplace, had become the major centre for art in Italy, after a lapse of a century when Rome had been the undisputed leader. Although much of Tiepolo's art is based on that of other Venetian painters, his fluent, rapid technique and cosmopolitan attitudes are closer to the work of Luca Giordano, the great Neapolitan, who died when Tiepolo was nine years old. Like Giordano, Tiepolo produced his greatest work in fresco, vast decorative performances in Germany and Spain as well as his native Venice – although not surprisingly the damp climate of Venice had never fostered a great tradition of fresco painting. But, again like Giordano, Tiepolo was also highly accomplished at painting altarpieces and small devotional pictures.

The re-emergence of Venetian art in the eighteenth century was accompanied by a corresponding demand for Venetian painting among foreigners, especially in northern Europe. Tiepolo frequently worked for German patrons, some of whom visited Venice, and he even travelled to Germany where he painted the frescoes at Würzburg. Clemens August, the Archbishop Elector of Cologne, commissioned from Tiepolo an altarpiece for a chapel at Nymphenburg for which this picture is the *modello*, or preliminary design.

What is remarkable about it is the high degree of finish, for Tiepolo's preliminary designs are often sketchy. It has all the qualities of his most complete and finished paintings. The final altarpiece, now in the Alte Pinakothek, Munich, is proportionally taller and thinner, making the Trinity, on a cloud with accompanying angels, appear higher and grander. But the compression of the final version removes the feeling of space which is so effortlessly depicted in the *modello*. (This is an aspect of Tiepolo's art that is especially important in his brilliant, airy frescoes.) Here St Clement is isolated as he kneels on the steps with the crisp, white architecture in the background: the appearance of the Trinity emphasizes this impression of spaciousness.

It is normal in Baroque painting to represent visions such as this as real events. The Virgin and Child appear countless times to a multitude of saints in seventeenth and eighteenth-century paintings. The Trinity was also a popular vision. St Clement, fourth Pope after St Peter, was a rare subject. But his appearance here is explained by the fact that the patron's name was Clement.

In Tiepolo's Trinity the golden radiance behind the heads of God the Father and Christ provides a suitably majestic background, while the brilliance of Christ's white robe and the blue and gold of the angels' drapery are integrated with the other scintillating colours in the picture. Indeed, it is the richness of the colouring which reminds us of the Venetian tradition of which Tiepolo was so strongly aware and which he brought, simultaneously, to a climax and an end.

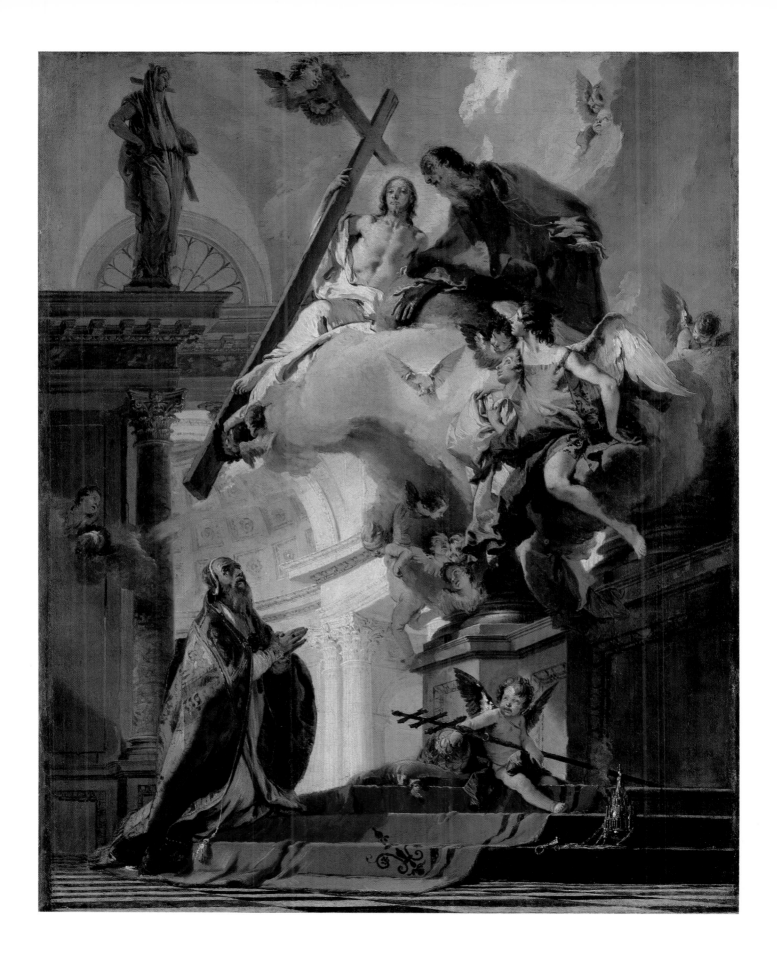

PLATE 42

Giovanni Battista Tiepolo, 1696–1770

The Banquet of Cleopatra (No. 6409)

Canvas, 44.2 × 65.7 cms.
Presented by the Misses Rachel F. and Jean I. Alexander
1972

One of the most profound influences on Tiepolo was the work of his great Venetian predecessor, Veronese. Veronese's grand banquet scenes, with their magnificent architectural settings, such as the *Feast in the House of Levi* (Venice, Accademia) or the huge *Marriage Feast at Cana* (Paris, Louvre) provided Tiepolo with direct inspiration for his interpretation of the Banquet of Cleopatra. The finest and most famous of the many versions Tiepolo made of this subject is in his preferred medium, fresco, at the Palazzo Labia in Venice, where an entire room is covered with his frescoes and a whole wall devoted to the subject which he represents here in a small sketch.

The story of Antony and Cleopatra, and this particular moment in it, especially appealed to Tiepolo. Cleopatra, having wagered Antony that she would spend a vast fortune on a banquet, dissolves one of her priceless pearls in a glass of vinegar which she then drinks. In some versions Cleopatra holds the pearl directly above the glass: in the sketch, while the pearl is held ready, the glass of vinegar is still being brought to the table on a tray, adding even more suspense to the already charged moment. It is a moment of operatic drama appropriate both to Venice, where opera thrived, and to the eighteenth century, when the art achieved some of its highest expressions.

This picture may be one of Tiepolo's early sketches for the Palazzo Labia fresco, although the two differ in many ways and the Palazzo Labia painting is a vertical composition. While the style in this picture is looser and more rapid than in his finished works Tiepolo nevertheless achieves great delicacy of colour, from the elegant cream silk of Cleopatra's dress, with its marvellous extravagant collar, to the subtle, slightly mottled pink of the flanking columns.

The very sketchiness of the picture enlivens the anecdotal elements: the dwarf on the step teasing the dog (an echo, perhaps, of the main scene); the man restraining the powerful horse, preventing the animal from blocking our view; the tension as the startled Antony and hushed onlookers await Cleopatra's next move. The technical ease with which Tiepolo includes these and many more incidents almost conceals the sheer power of his imagination.

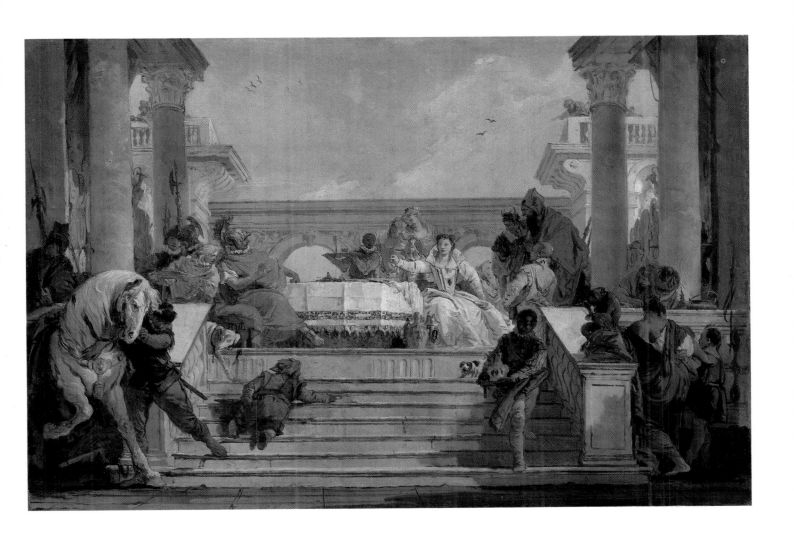

PLATE 43

Giovanni Battista Tiepolo, 1696–1770

An Allegory with Venus and Time (No. 6387)

Shaped canvas, 292.1 × 190.4 cms.
Purchased with the aid of a Special Grant and a
contribution from the Pilgrim Trust 1969

It is impossible to gain a complete impression of Tiepolo's genius without being aware of the fresco decorations he painted on the walls and ceilings of some of the great palaces of Europe. He transformed mere plaster into wide open skies, full of light, populated by airborne deities but never over-crowded with weighty bodies, like many ceiling paintings of the previous century. In Venice the damp climate sometimes made frescoes unstable and Tiepolo would paint ceiling decorations on pieces of shaped canvas, as here.

Until the mid-nineteenth century this *Allegory of Venus and Time* was in one of the palaces of the Contarini family. Several palaces in Venice, the Ca' Rezzonico, for example, still have *in situ* painted ceilings by Tiepolo. Although his fluency of style complemented the great range of subjects he covered, Tiepolo's finest decorations – Würzburg, Palazzo Labia and the Royal Palace in Madrid – are classically based, allegorical subjects.

While the main protagonists are easily identifiable, the meaning of the allegory in this picture remains unclear. Venus consigns the wide-eyed child to the venerable winged figure of Time who has, for the moment, put down his scythe. Cupid, Venus' son, cavorts below, clutching a huge sheaf of his arrows, while Venus'

doves, high in the clear, blue sky, remind us that she is the Goddess of Love.

It is possible that the child represents Aeneas, another son of Venus, to whom Time is to give immortality, hence his putting down the scythe. But the allegory could have a more specific significance for the Contarini family: Tiepolo may have been commissioned to paint the ceiling to celebrate and commemorate the birth of a Contarini son. To show the child being passed from the Goddess of Love into the care of Time, with Cupid waiting nearby, would indicate a highly auspicious start in life. But there is no evidence that such an event took place in the mid-1750s, when the picture was painted.

The beautiful figure of Venus is especially striking, as are the women in many of Tiepolo's paintings. (He had married Cecilia Guardi, sister of the painter, Francesco, in 1719.) Tiepolo's sensitivity to feminine beauty ensured that the loveliness of the women he portrayed was always enhanced by the grandeur and grace of their bearing, frequently dominating the males in both religious and allegorical scenes such as this. Yet along with the grace and elegance of Tiepolo's paintings his art is filled with frank, openly felt pleasure.

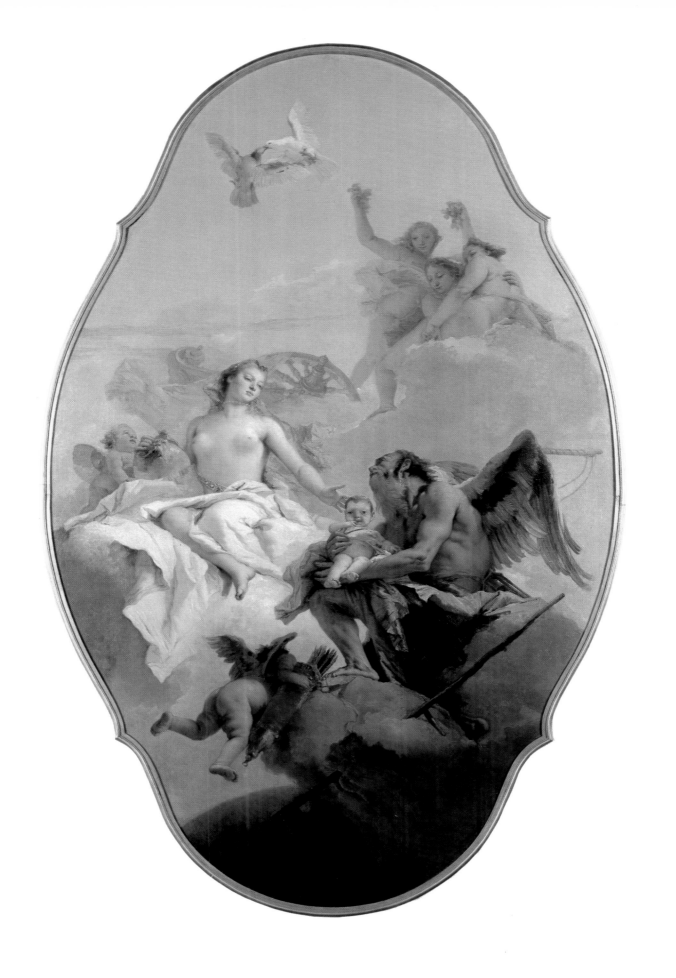

Giovanni Domenico Tiepolo, 1727–1804

The Building of the Trojan Horse (No. 3318)

Canvas, 38.8 × 66.7 cms.

The Procession of the Trojan Horse into Troy

(No. 3319)

Canvas, 38.8 × 66.7 cms.
Both purchased 1918

Domenico Tiepolo's reputation has always been overshadowed because of the brilliance of his father's career. Until G. B. Tiepolo's death in Madrid in 1770 his sons Domenico and Lorenzo often collaborated on the largest schemes. Domenico travelled with his father to both Germany and Spain but also worked independently. Close proximity for so long to so great a painter as his father inevitably resulted in Domenico's work having many similarities to (and often a quality approaching that of) his father's paintings. Both these pictures have in the past been attributed, like much of Domenico's work, to his father – an indication of their high quality.

These two paintings, probably sketches, form part of a series illustrating the story of the Trojan Horse: another picture (possibly in a private collection in Paris) shows the Greek soldiers descending from the horse inside the city of Troy. The Trojans, for whom the horse was a sacred animal, were deceived by the Greeks, who built a vast wooden horse, concealing some of their finest soldiers inside. Believing it was a gift from the gods, the Trojans wheeled the horse inside the impregnable walls of Troy with great feasting and celebration. Later the Greek soldiers, Ulysses among them, emerged and began the disastrous sack of the city as the Trojans slept, heavy with wine.

Virgil's *Aeneid* (Book II) gives the clearest account of this story. As the horse is being drawn into the city Virgil writes of Cassandra who tried, in vain, to warn the Trojans of their fate. Domenico Tiepolo shows Cassandra, surrounded by soldiers, at the centre of the picture, behind the knee of the horse which is being towed. Virgil also specifically refers to the boys and girls (*'pueri . . . innuptaeque puellae'*) who enthusiastically drag the horse towards the large rejoicing crowd.

Both the pictures are full of action. Several men are engaged in the building of the horse, hammering, chiselling and painting. But Domenico remains sensitive to apparently minor yet human details: for example, the painter's leg resting gently on the hind leg of the horse; or the waving arms of the people rejoicing on the battlements of Troy. This anecdotal touch is also strong in his father's work. From him Domenico also learnt the skills of draughtsmanship and colouring, although in these pictures, perhaps because they are sketches, the colour is restrained.

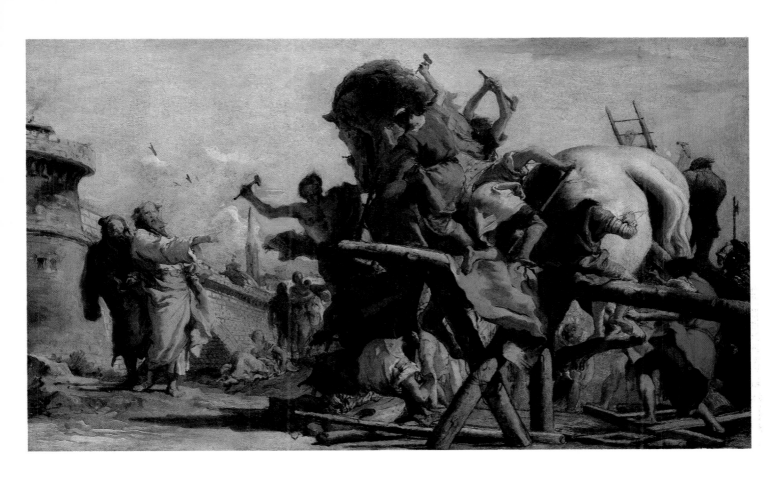

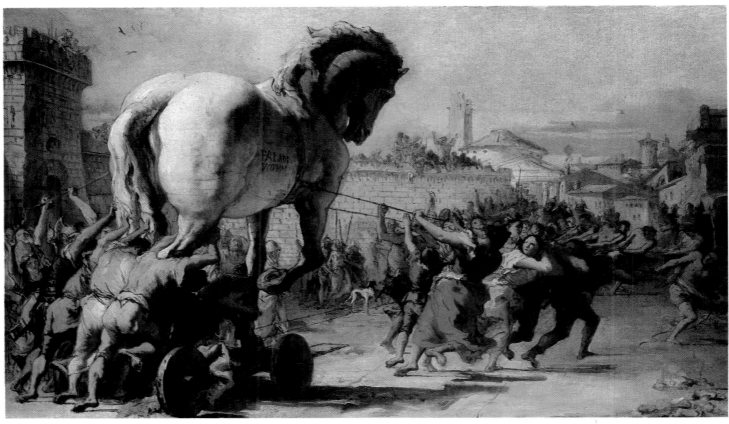

PLATE 45

Giovanni Antonio Canal, *called* Canaletto, 1697–1768

Venice: Campo S. Vidal and S. Maria della Carità (No. 127)

['The Stonemason's Yard']

Canvas, 123.8 × 162.9 cms.
Sir George Beaumont Gift 1824

This picture is generally regarded as Canaletto's masterpiece: and although it is not the kind of painting English travellers usually required of the artist it is entirely appropriate that it should be in England. For it was above all for the English that Canaletto worked, even to the extent of spending several years in London. This painting is altogether too informal and intimate to be considered alongside the various series of famous Venetian scenes Canaletto painted for the travelling English '*milordi*'. It must have been painted for a patron, probably Venetian, sensitive to the beauty of the less well-known parts of the city. The picture also reveals the depth of Canaletto's own sympathy for Venice.

The decade of the 1720s, towards the end of which 'The Stonemason's Yard' was painted, was the time when Canaletto both began and established his career as a view painter. At first he had assisted his father painting scenery in the theatre, probably visiting Rome. In 1722 he is known to have painted the backgrounds to certain pictures commissioned by the Irishman Owen McSwiney, who was then living in Venice. It was his reputation as a theatrical scene-painter that secured him this work. After this solid training and having learnt the art of figure painting, it was a natural step for Canaletto to turn to view painting: and by the mid 1720s he was becoming well-known. His works of this early period are clearly distinguishable, being bold and solid in composition with rich colouring. They are inhabited by big, fluently painted people, who differ greatly from the rather 'blobby', almost shorthand figures of his later work.

It is Canaletto's early style that forms the basis of 'The Stonemason's Yard'. But although it conforms to the work of this period in that the design is striking, the scene informal and the colouring rich there is a control in the composition unique to this painting. While it displays Canaletto's sensitivity to everyday life in an ordinary yet beautiful part of Venice it is also one of his most brilliant technical creations.

The building of the nearby church of S. Vidal (not visible in this picture) had caused the Campo to be transformed into a depositary for the huge blocks of Istrian stone, brought by barge along the Grand Canal, which were then cut and used to build the façade of the church. A wooden hut had been erected to one side of the Campo for the masons' use. But for the local inhabitants life continues normally: a woman sits in her window (on the right) spinning in the morning sunshine: another draws water from the well and, on the left, a small family drama upsets the daily routine rather more than the masons working in the Campo. As in all his work Canaletto gives minute attention to details: washing on a line, the masons' tools, the plant pots and shabby plasterwork.

It is especially poignant that, apart from certain alterations, this humble scene, like the grander sights of Venice, is clearly recognizable today. Even the well-head remains.

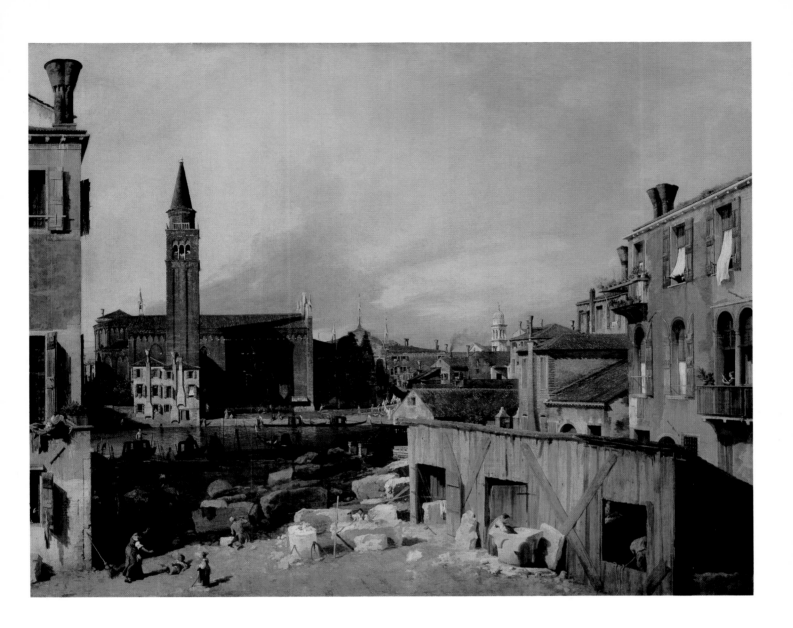

PLATE 46

Giovanni Antonio Canal, *called* Canaletto, 1697–1768

Venice: The Feastday of St Roch (No. 937)

Canvas, 147.7 × 199.4 cms.
Wynn Ellis Bequest 1876

Recent cleaning of this picture has revealed the ruled lines and holes of compass points that are present in many of Canaletto's paintings, techniques that often earned him the accusation of being a dull, mechanical painter. But this is to misunderstand Canaletto's intention of creating pictures that were topographically accurate as well as beautiful. *The Feastday of St Roch* is one of Canaletto's finest achievements on both these counts. He has recorded the buildings accurately, always allowing the intrinsic beauty of the architecture to speak for itself. But he nevertheless organized the composition in order to emphasize this in the most advantageous way, even if that meant he had to 'rearrange' the scene a little. Here, for example, the faultlessly accurate buildings, especially the grand façade of the Scuola, dominate the picture: yet the viewpoint is false, the composition contrived. In order to have this view of the scene Canaletto would have to have been standing inside the nearby church of the Frari. But due to the skill of the arrangement (the painter's imagination) the illusion is not at all disturbing, even for those who are familiar with the buildings, which still exist.

The scene Canaletto has depicted is one of the ceremonial occasions so important to Venetian life: although the scale of this event is rather more modest than those shown in the following pictures it was nonetheless a grand occasion. The Doge visited the Scuola and church of S. Rocco annually on 16 August, the saint's Feastday. The visit commemorated the end of the terrible plague of 1576: this was the plague after which Palladio's votive church of the Redentore was built, and which claimed, among many others, the life of Titian.

Along with the architecture the most striking aspect of this picture is the great frieze of figures lined across the scene. It has been suggested, without any foundation, that these figures were painted by Tiepolo, implying that Canaletto would have been incapable of the sort of quality: but one need only look at 'The Stonemason's Yard', painted five or six years earlier, to be made aware of Canaletto's abilities.

In this view Canaletto has provided one of the most attractive and detailed images ever painted of the rulers of Venice: the Doge is in his ceremonial robes of gold and ermine (in spite of the heat of August) with a parasol and awning to give him double protection from the sun. Around him are his officers of state: the *Cancelliere Grande* in scarlet, the secretaries in mauve. Behind the Doge, still leaving the church, are the senators, also in scarlet, and ambassadors, many still in the shadow cast by the enormous bulk of the church.

Meticulously and typically Canaletto has recorded two small details peculiar to this ceremony. All the participants have been given nosegays, reminders of the horrors of the plague. There are also paintings shown hanging on the façade of the Scuola and other buildings: this had become a traditional feature of the St Roch ceremonies. It is typical of the Venetians that the remembrance of an event so ghastly as the plague should be turned into such a flamboyant and ostentatious occasion.

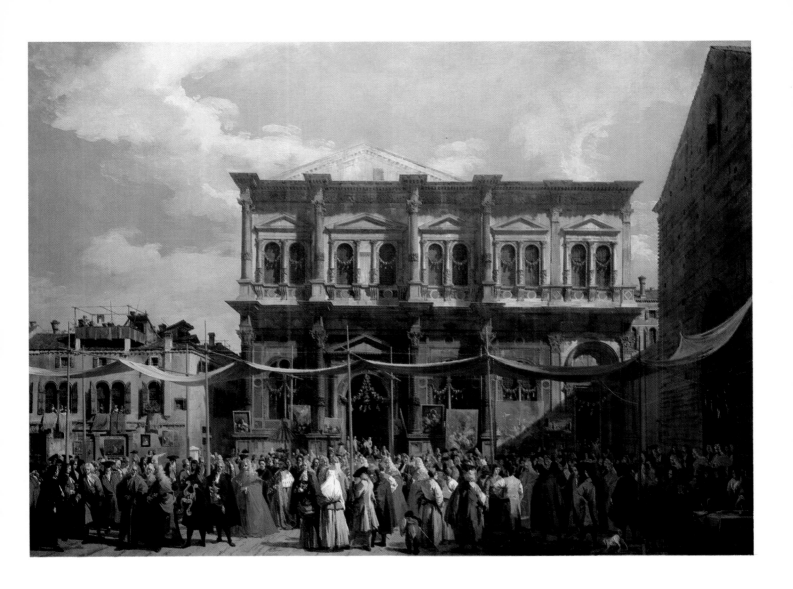

Giovanni Antonio Canal, *called* Canaletto, 1698–1768

Venice: The Basin of S. Marco on Ascension Day (No. 4453)

Canvas, 121.9 × 182.8 cms.

Venice: A Regatta on the Grand Canal (No. 4454)

Canvas, 122.1 × 182.8 cms.

Both bequeathed by Lord Revelstoke 1929

These paintings are of the very grandest type Canaletto made for certain visitors to Venice. The pair may have been commissioned by the Duke of Leeds who had visited Venice, as they were first recorded in the Leeds collection during the nineteenth century. They are the kind of pictures that made Canaletto one of the most sought-after painters with English travellers: the impressive ceremonies of Venice were among the great spectacles of Europe.

One of the most ancient ceremonies in Venice was that of the Wedding of the Sea which took place on Ascension Day. It commemorated a naval victory of around 998 and every year Venetian supremacy over the sea was celebrated when the Doge threw a ring that had been blessed into the Adriatic. The Doge was rowed out to the Lido in his vast ceremonial barge, the *Bucintoro*. This journey of the splendid gilded boat was one of the finest sights of the year for both Venetians and tourists alike: they gather in the flotilla of crowded gondolas that accompanied the Doge out to the Lido and back.

The ceremony of the Wedding of the Sea ended when the Republic fell to Napoleon in 1797. But tourists still flock to the Regatta today. Originally a more technical exercise in the odd Venetian method of rowing, the Regatta developed into one of the great ceremonial spectacles for which Venice was so famous. The Grand Canal was (and is) a spectacle in itself, lined with the palaces of the Venetian nobility: but arrayed with the extravagant, decorated boats full of colourfully dressed people watching the race, the Regatta became another highlight of the Venetian calendar.

These ceremonies gave Canaletto ample opportunity to show off his skills, not only as an accurate view painter recording the scene, but as an artist who relished the decorative profusion and brilliance to which he always responded enthusiastically. But over and above the excitement and froth of the decorated gondolas or the sparkling *Bucintoro* Canaletto remained sensitive to his ideal of Venice, with the beautiful buildings taking the clear light, dominating the scenes under a serene sky.

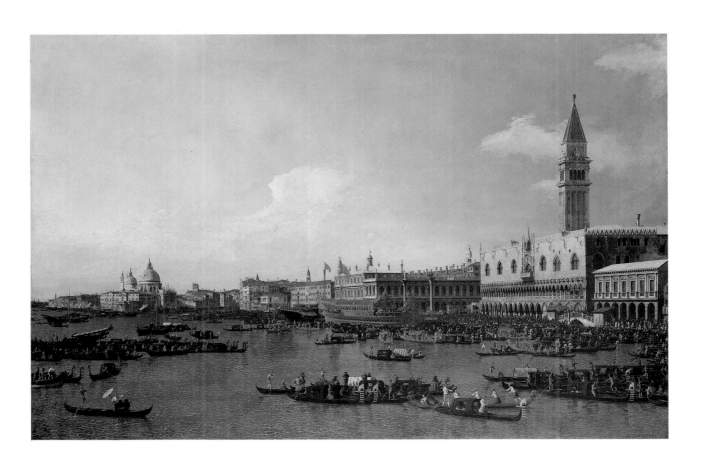

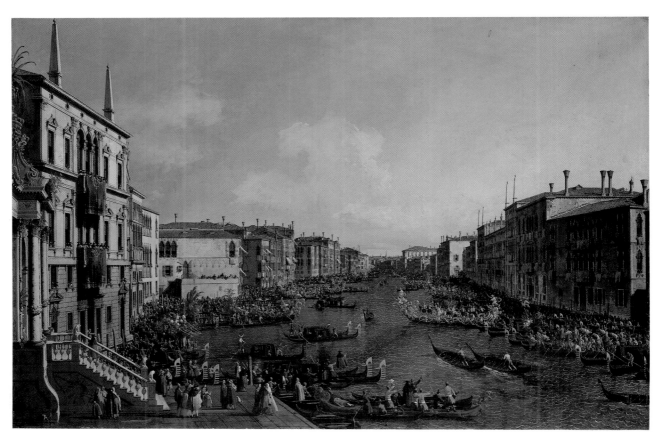

PLATE 48

Francesco Guardi, 1712–1793

Venice: The Piazza S. Marco (No. 210)

Canvas, 72.4 × 119.1 cms.
Bequeathed by Richard Simmons 1846

When Guardi began painting views he was already a mature artist, approaching middle age. Until then he had been working in the workshop run by his family producing mainly religious paintings. He may have felt that he needed to become more independent of his then better-known brother, and with Canaletto's example before him, would have realized that a good view painter was assured of success. But this is not the only reason for Guardi's change: it is important to understand that, as a native Venetian, Guardi's vision of Venice, although different from that of Canaletto, was just as 'true' and based on a deep sympathy with the city itself.

The Piazza S. Marco is one of Guardi's earliest view paintings, dating from around 1760. In its clear style and composition it differs from both the religious pictures he had earlier worked on and his later view paintings. Here he has deliberately emulated the style of Canaletto, reconstructing the view as if it were a theatrical set. Canaletto, who served his apprenticeship as a scene-painter in the theatre, also built up his early paintings in a theatrical way. It was through the study of Canaletto's pictures, specially the early ones, that Guardi developed the precise techniques essential for view painting. It has been suggested that Guardi even became a pupil of Canaletto: but it is unlikely that Guardi, middle-aged and experienced, would have wished to work with Canaletto, reputedly a rather difficult, irritable man. The two artists probably knew each other but any actual teaching was likely to have been informal.

Although Guardi's style is seen here at its closest to Canaletto's there are certain aspects of his later, more typical view paintings already present. He has emphasized the delicate silvery silhouette of the basilica at the end of the square: he makes it appear even brighter by painting the two sides of the square, the Procuratie Nuove (on the right) and the Procuratie Vecchie (on the left), the same dark colour, even though the one is in sunlight and the other in deep shadow. Most striking is Guardi's treatment of the great campanile which in this picture appears taller, slimmer and more graceful than it really is. While Canaletto's interpretation of the facts before him is usually concise and accurate, Guardi's interpretation of the same scene often strays into poetic fancy.

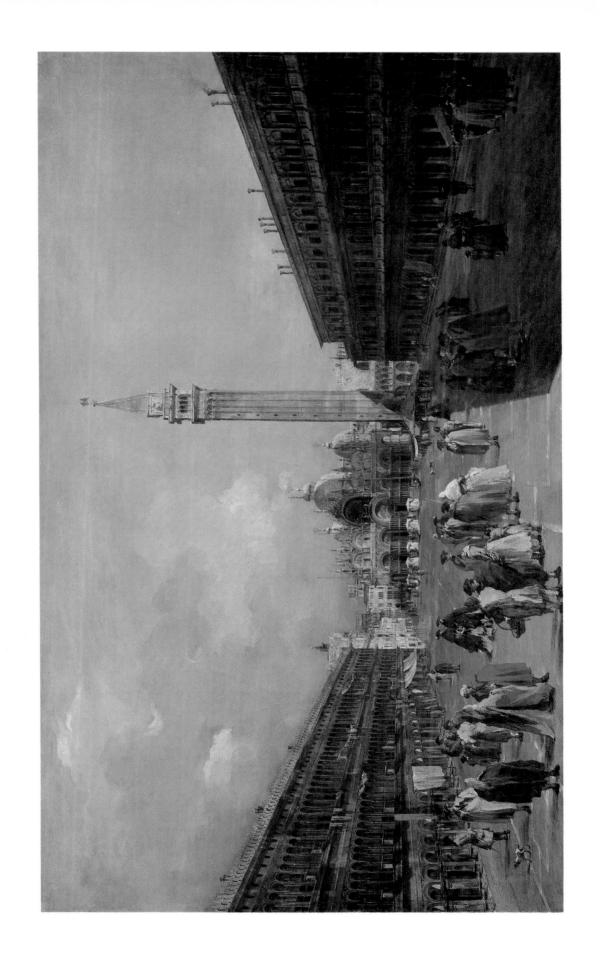

PLATES 49a and b

Francesco Guardi, 1712–1793

Venice: The Punta della Dogana with S. Maria Della Salute (No. 2098)

Canvas, 56.2 × 75.9 cms.

Venice: The Doge's Palace and the Molo (No. 2099)

Canvas, 58.1 × 76.4 cms.

Both bequeathed by Miss Cohen 1906

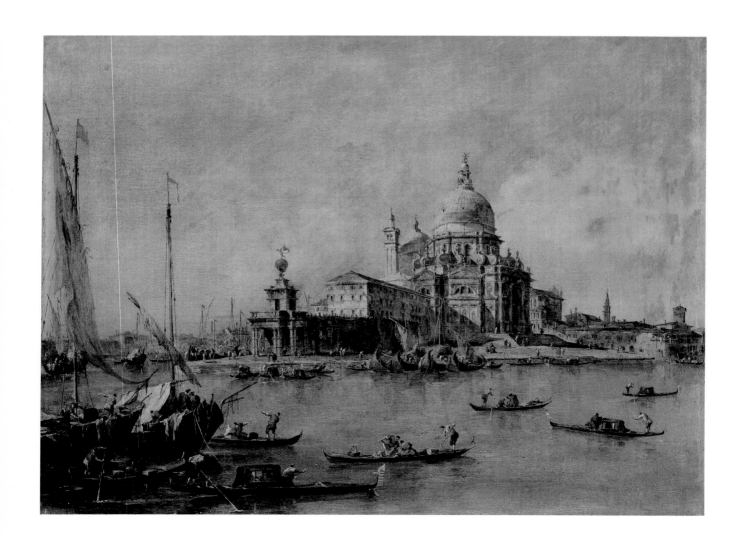

Both these views can be seen in Canaletto's picture of the Basin of St Marco on Ascension Day (plate 47a). But Guardi's paintings depict scenes of everyday life rather than ceremonial occasions.

The huge dome of the votive church of S. Maria della Salute, begun in 1631 to mark the end of the plague, dominates the entrance to the Grand Canal. In front of the church, at the point where the Grand and Guidecca canals meet, is the Customs House, the Dogana da Mar, built in the 1670s: its distinctive golden ball is surmounted by a weather vane in the form of Fame.

In the other view it is the Doge's Palace which dominates the picture: never a fortified castle, it is a fantasy of gothic tracery and sculpture over which a lozenge pattern of pink Verona and white Istrian marbles blend to form the delicate colouring of the building. Behind the palace are the domes and campanile of the basilica of S. Marco.

Beyond the Doge's Palace are the Library and State Granaries, the latter now demolished, outside which is moored the Ducal Galley. This was the vessel used by the Doge on all State occasions other than the Ascension Day ceremony.

Although the majority of Guardi's paintings differ greatly from those of Canaletto in style, the fact that they were both Venetians, almost contemporaries, working in their native city, makes comparison inevitable. One may consider Canaletto to be clear and precise while Guardi is too sketchy: or Canaletto may appear mechanical while Guardi is poetic. But both their visions of the city are equally 'true' and, without belittling the achievement of either artist, it is to the poetry of Venice that one must look for their common source of inspiration.

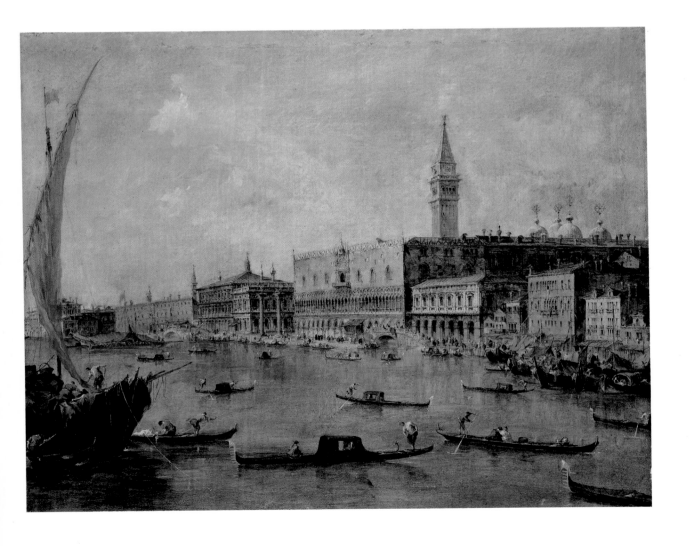

PLATE 50

Francesco Guardi, 1712–1793

View on the Venetian lagoon with the Tower of Malghera (No. 2524)

Panel, 21.3 × 41.3 cms.
Salting Bequest 1910

Although Guardi, when he began to paint views, emulated Canaletto's style and methods, he soon returned to the looser, sketchier style in which he had previously worked with his brothers: he applied this style, which seemed more natural to him, to view painting. This resulted in some extremely personal and poetic interpretations of Venice and the surrounding lagoon.

The Torre di Malghera, demolished in the mid-nineteenth century, formed part of the Venetian system of fortifications: the city itself had none, being protected naturally by the lagoon whose navigable channels were known only to the Venetians. Canaletto had made an engraving of this tower in the 1740s which, although Guardi knew it, did not form the basis for this composition.

This is one of the most serene of Guardi's paintings. The colours of the tower, sky and water blend into the delicate grey-green tonality so typical of Venice when the sun is not shining. But this calm scene would be monotonous had Guardi not broken it up with the little fishing boat, spikey and black with small figures and tall sweeping masts.

Like Canaletto's 'Stonemason's Yard', this is a personal view of the city known for its pageantry and lavish, opulent beauty. This glimpse, however small and apparently insignificant, is a Venetian's view of Venice.

Index to Plates

Note: page numbers throughout refer to the position of the illustrations